Nature Odyssey

A WILD COLORING JOURNEY

CHRIS GARVER

Get Creative 6

New York

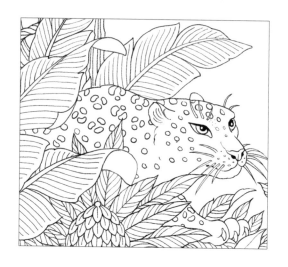
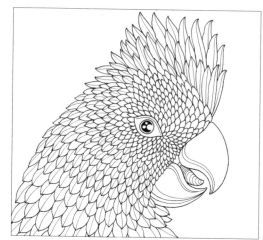
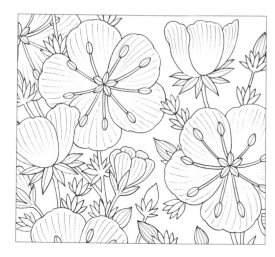

Travel the world through Chris Garver's art.

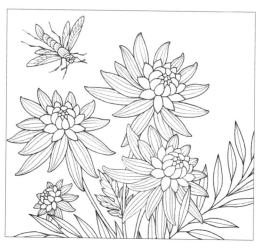
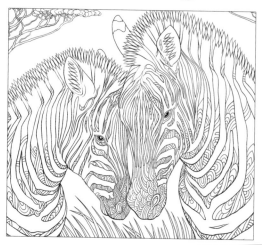
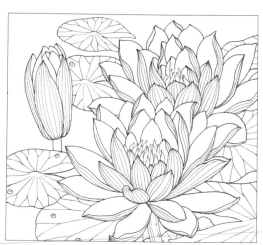

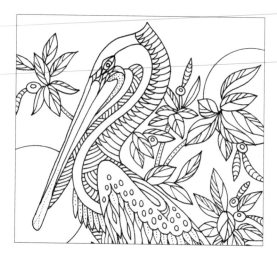
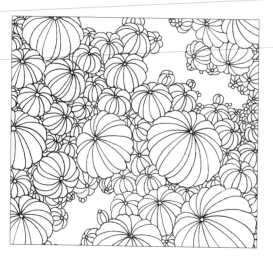
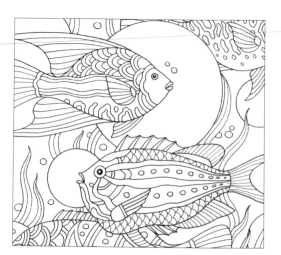

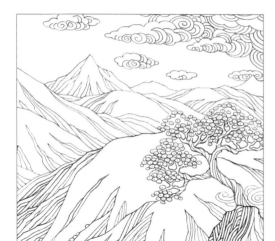
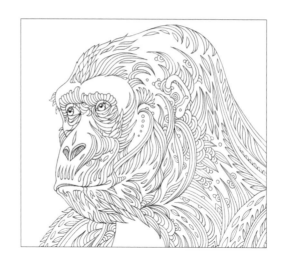

⊸◆ To my daughter, Nyarah

INTRODUCTION

Like many artists, I've always loved drawing animals, flowers, trees, and landscapes. Many of my tattoo designs are inspired by plants and animals and their organic shapes and patterns. My first coloring book, *Color Odyssey*, included lots of images of nature, but not exclusively. My most recent one, *Animal Odyssey*, focused on animals. For this one, I decided to expand that to all aspects of nature. There is so much variety that the hard part was deciding what *not* to include.

Let the nature odyssey begin...

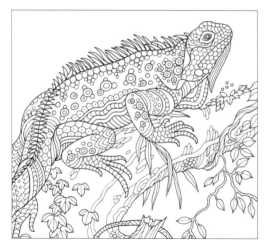
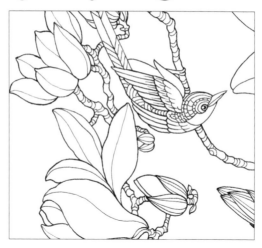

One of the cool things about drawing animals is that many of them have patterns: feathers, scales, spots, stripes. That makes them great subjects for complex coloring images. But I like to go beyond that, adding patterns to make them more interesting and intricate to color. Plants, flowers, and landscapes also have patterns that lend themselves to coloring, but I enjoyed amping them up as well.

Just as I had fun playing with patterns, feel free to let your imagination run wild when you're coloring these drawings. You don't have to use realistic colors or even colors found in nature. Even though I drew the pictures, by coloring them you make them your own.

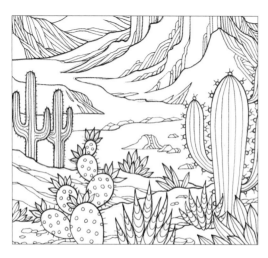

The subjects in this book come from all over the world--from the African savanna to the Australian Outback and from the bottom of the ocean to snow-capped mountains. Doing the research for this book and drawing these familiar and exotic animals and landscapes made me feel like I was traveling the world from the comfort of my drawing table. When you color in these images, you can travel along with me. I hope you'll share your work with the hashtag #natureodyssey.

—CHRIS GARVER

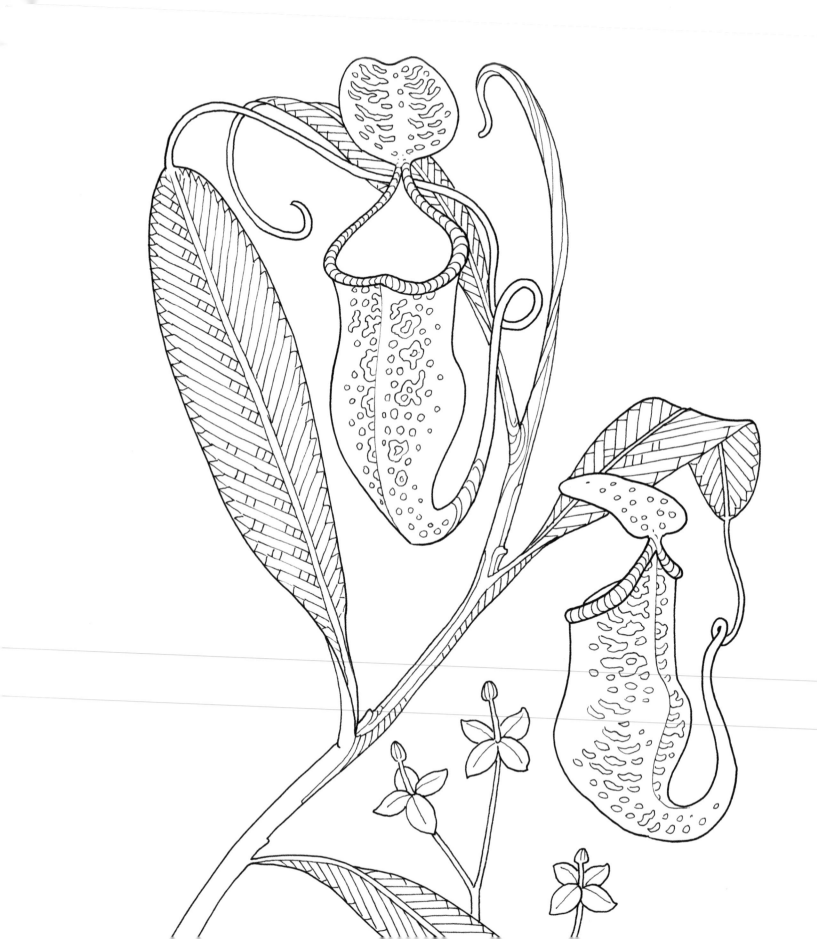

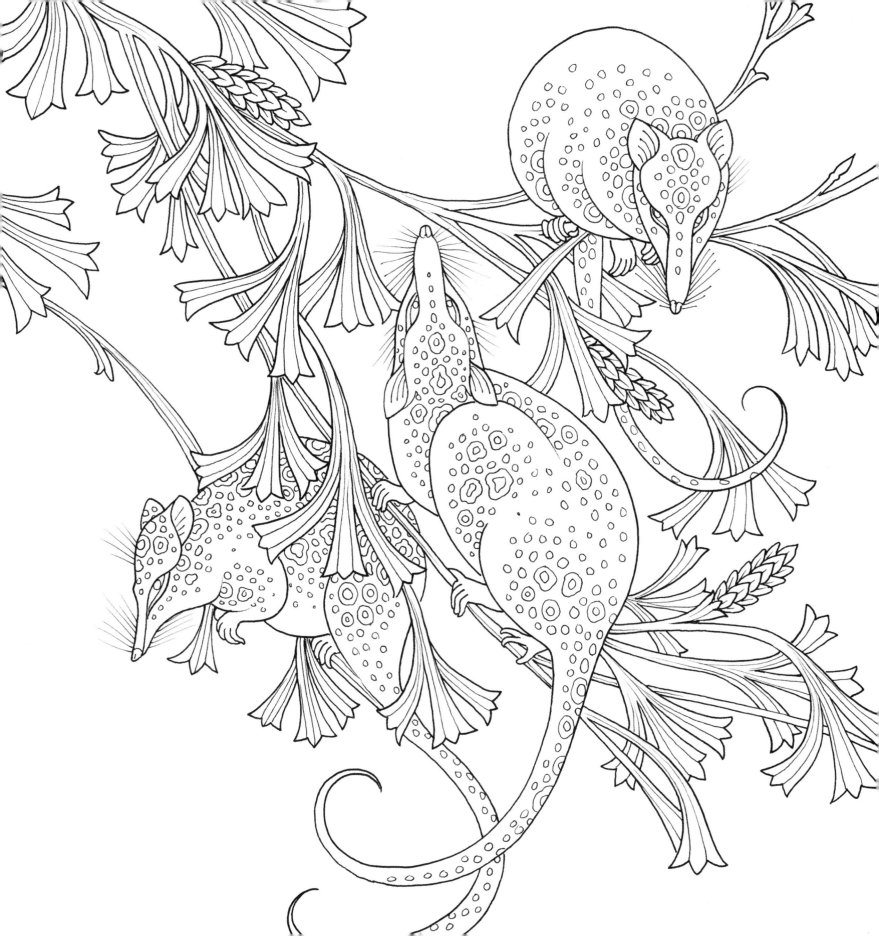

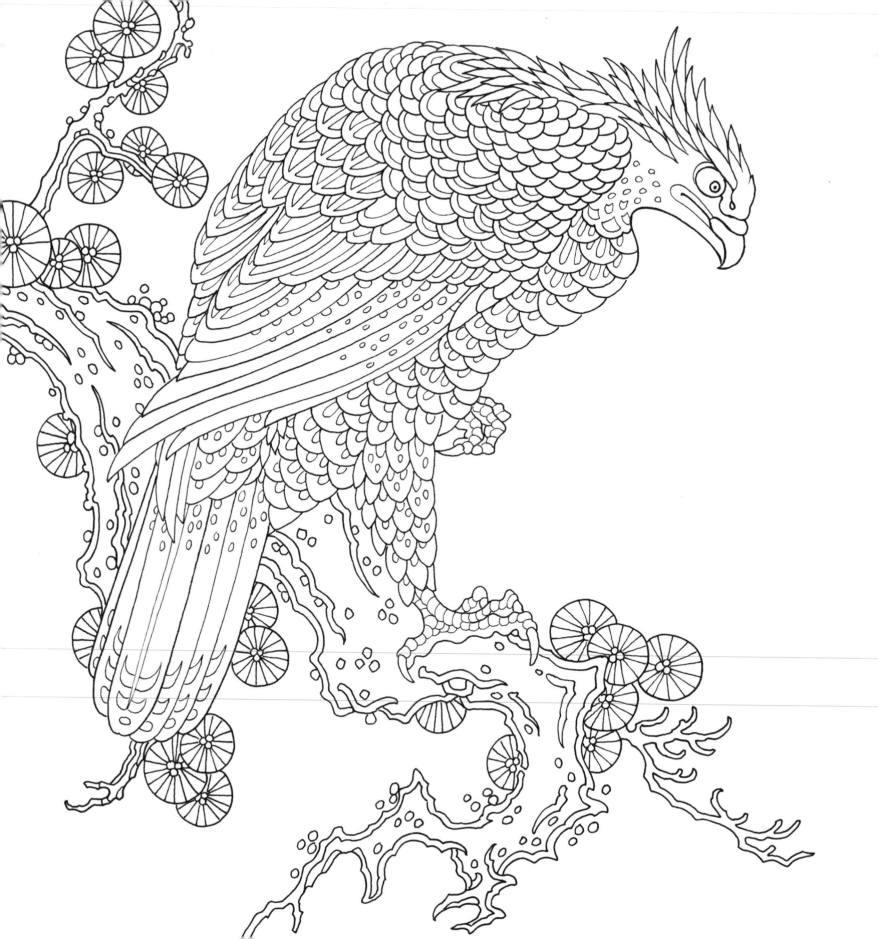

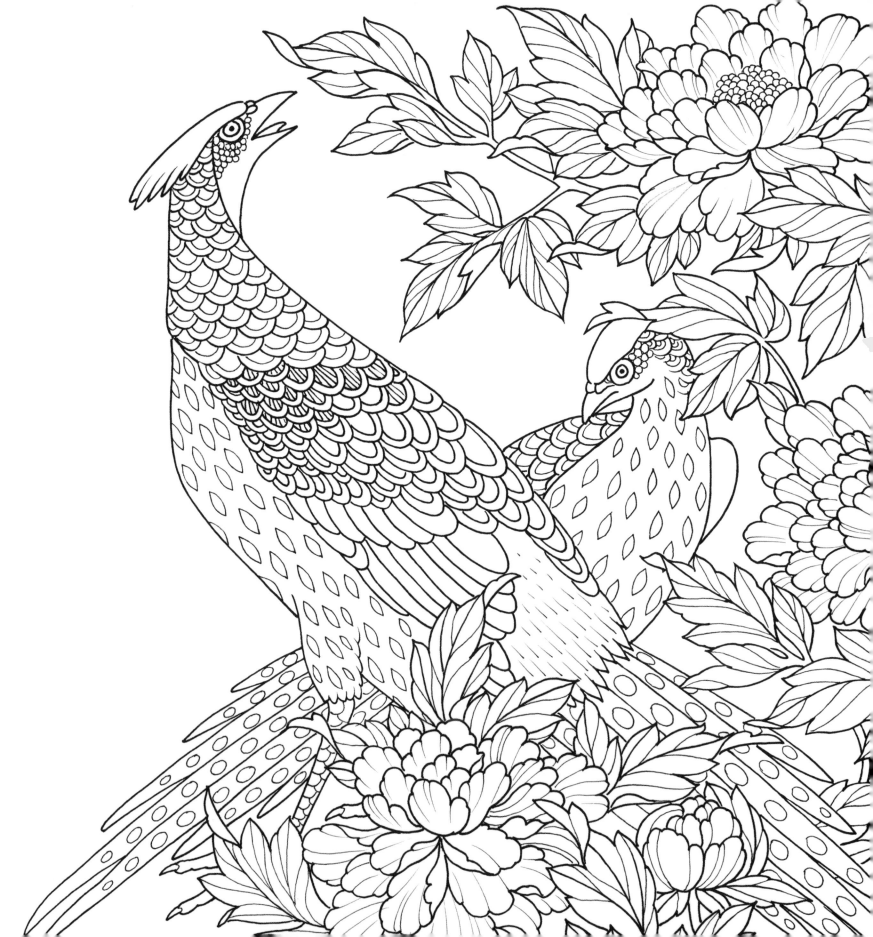

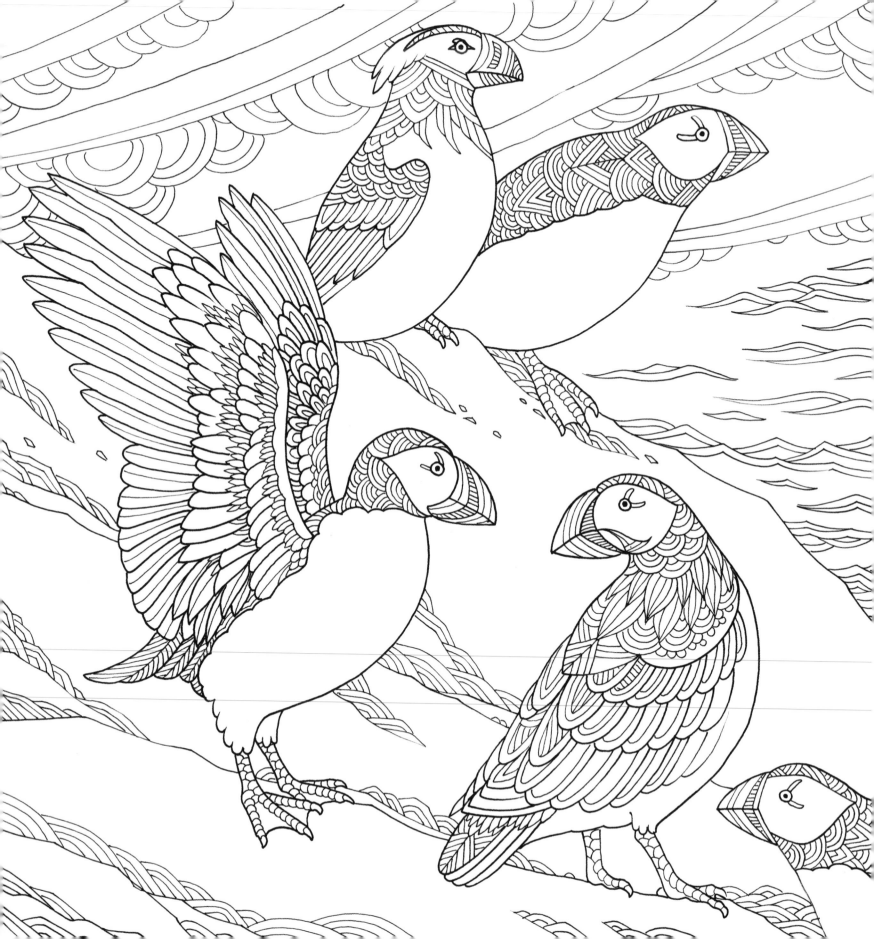

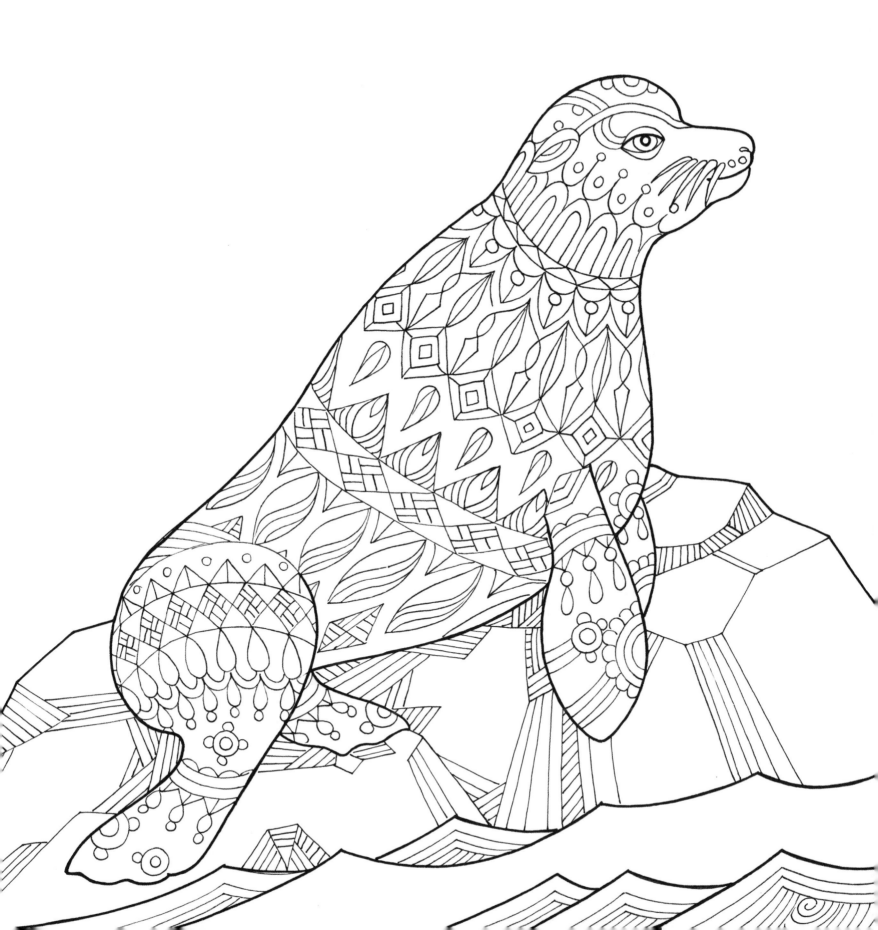

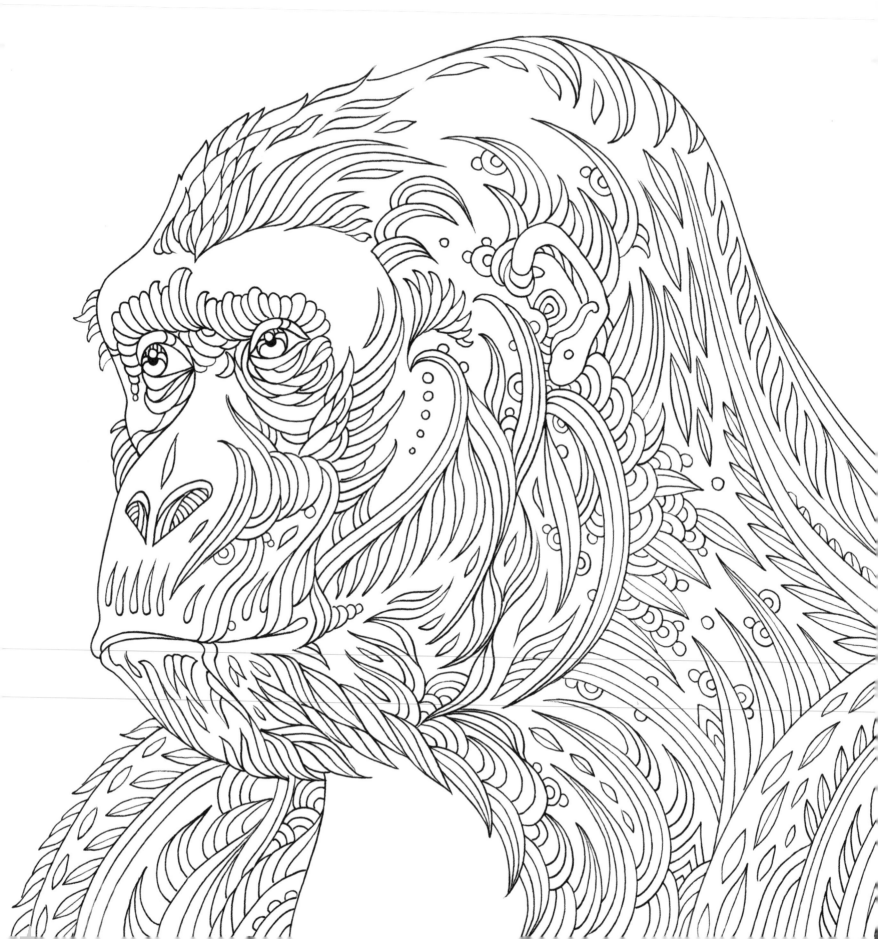

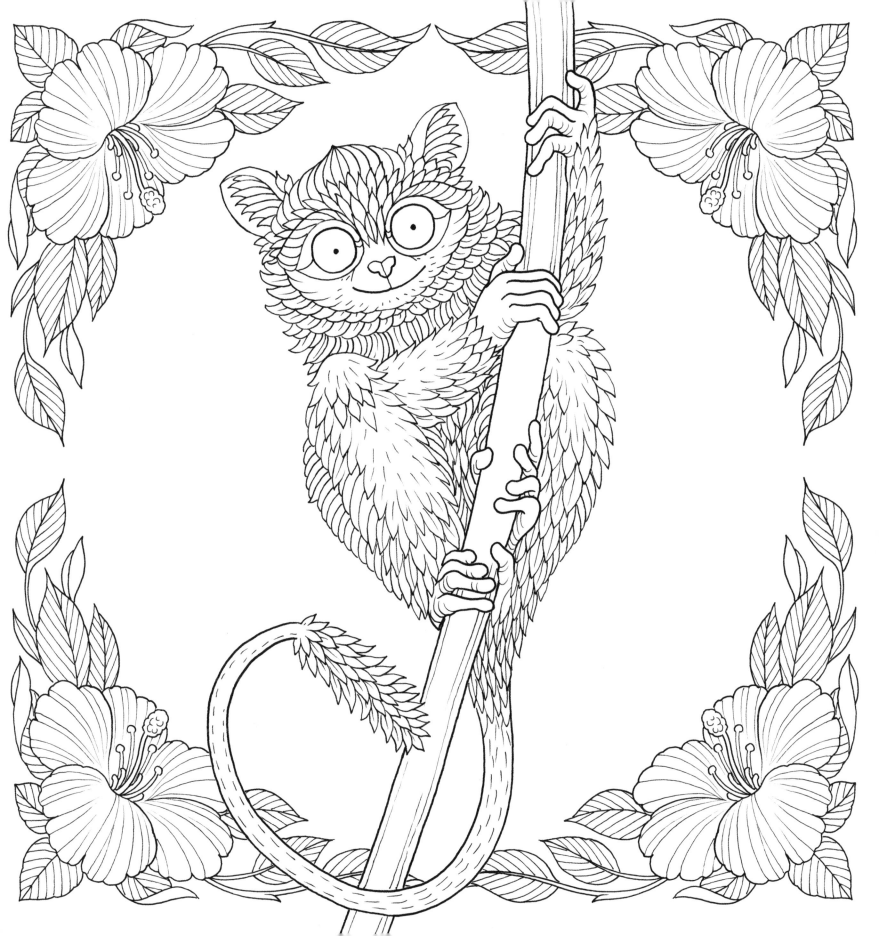

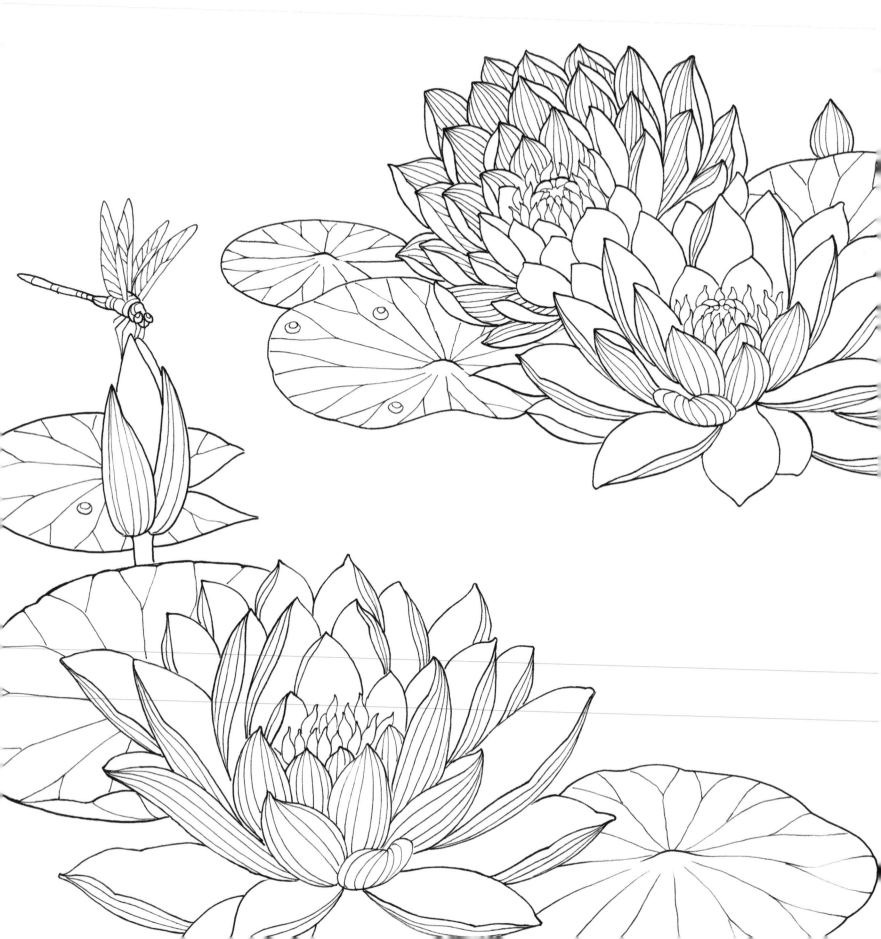

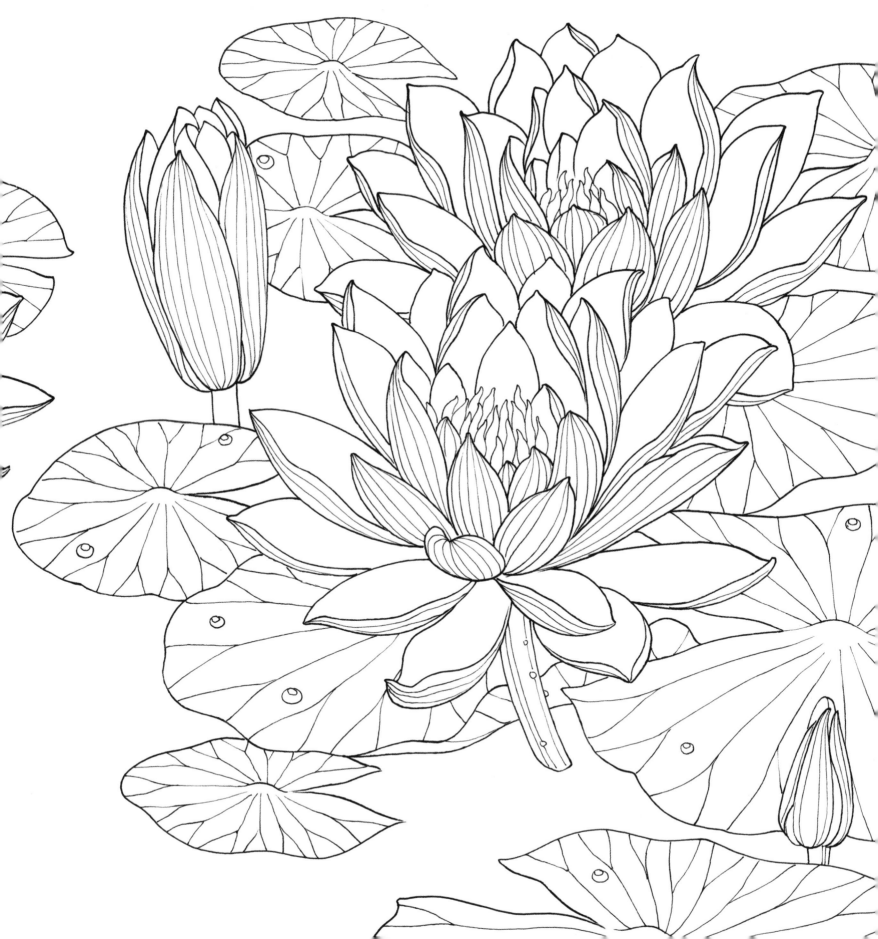

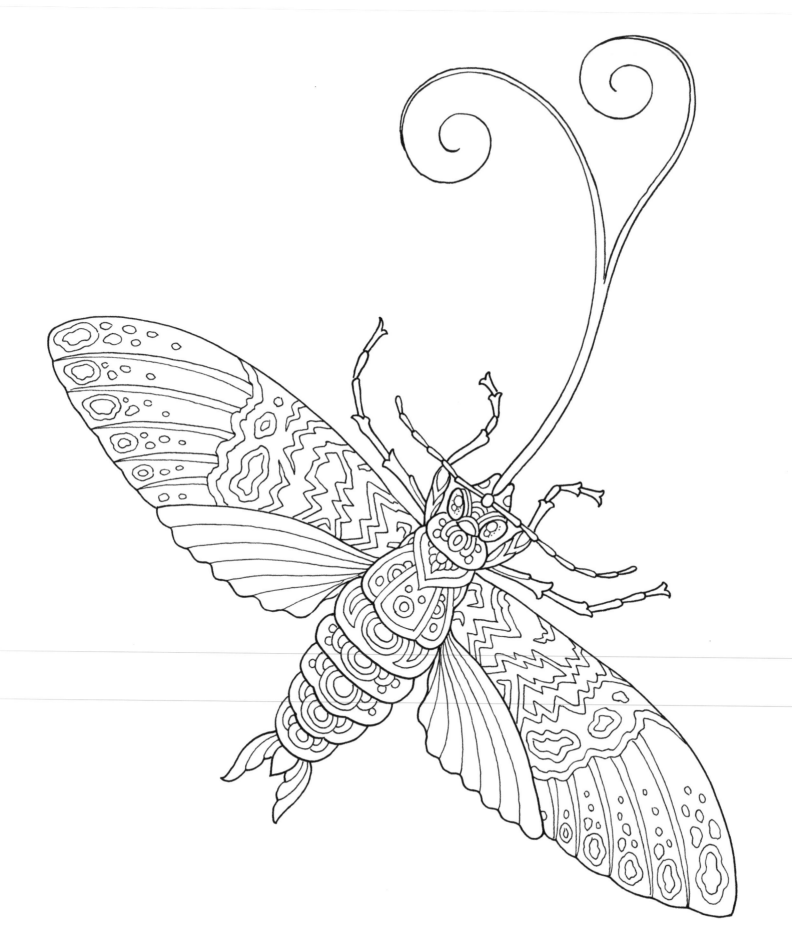

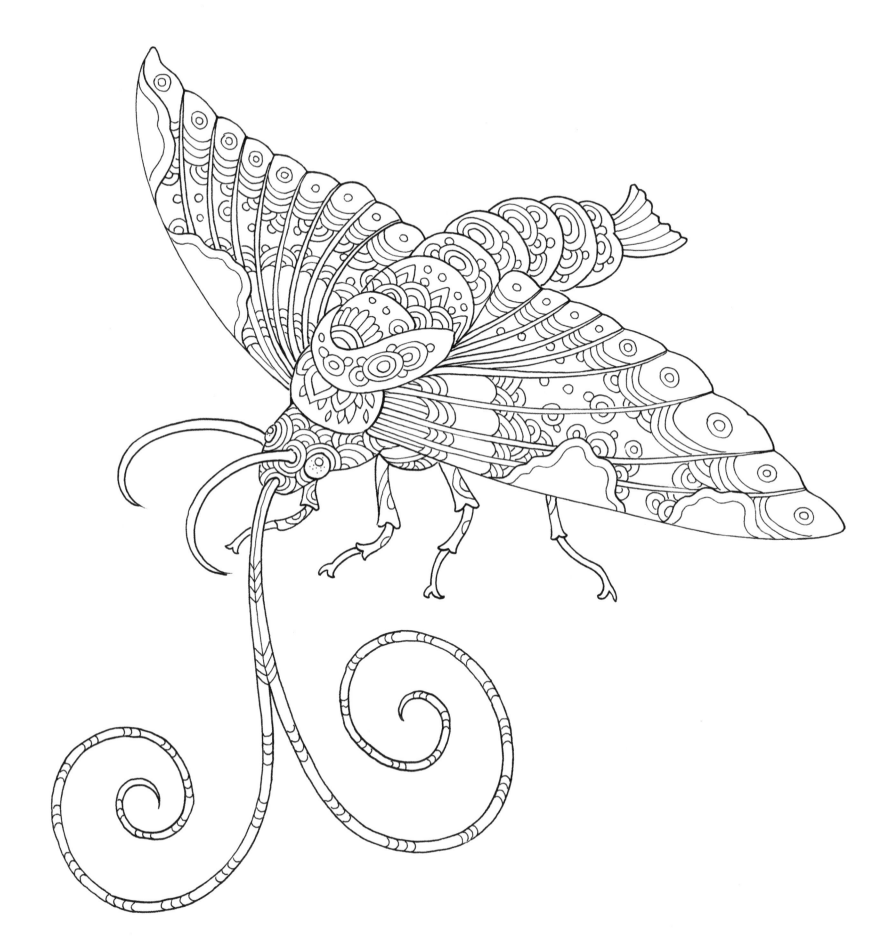

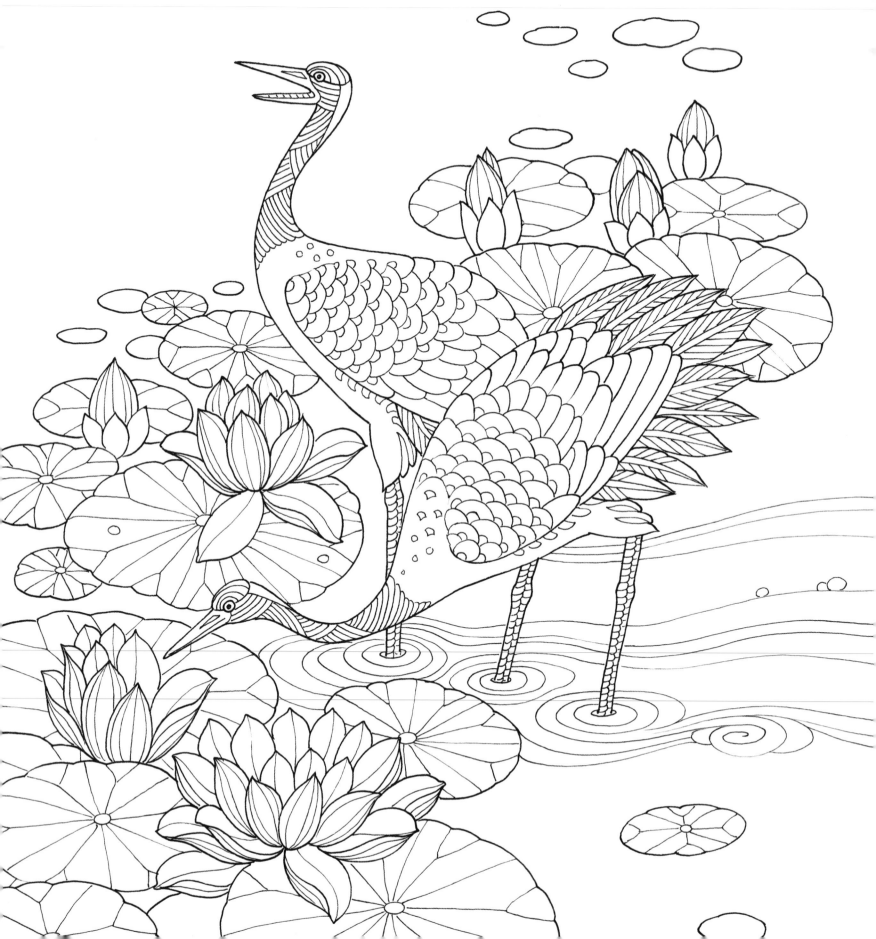

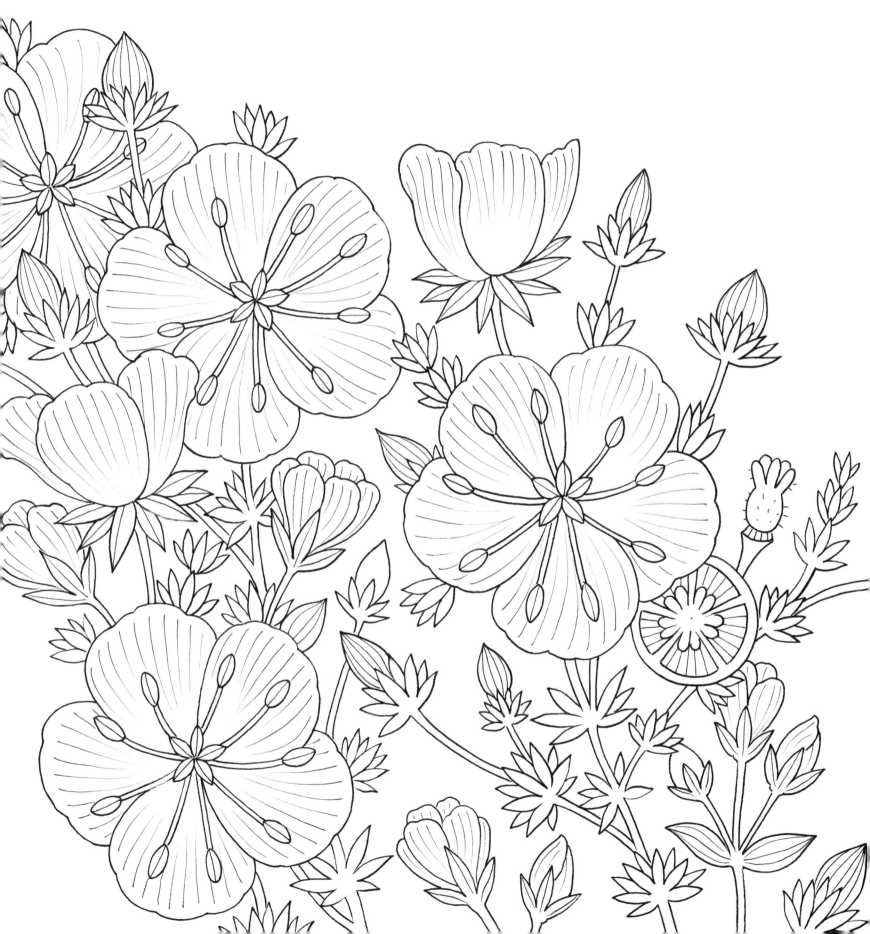

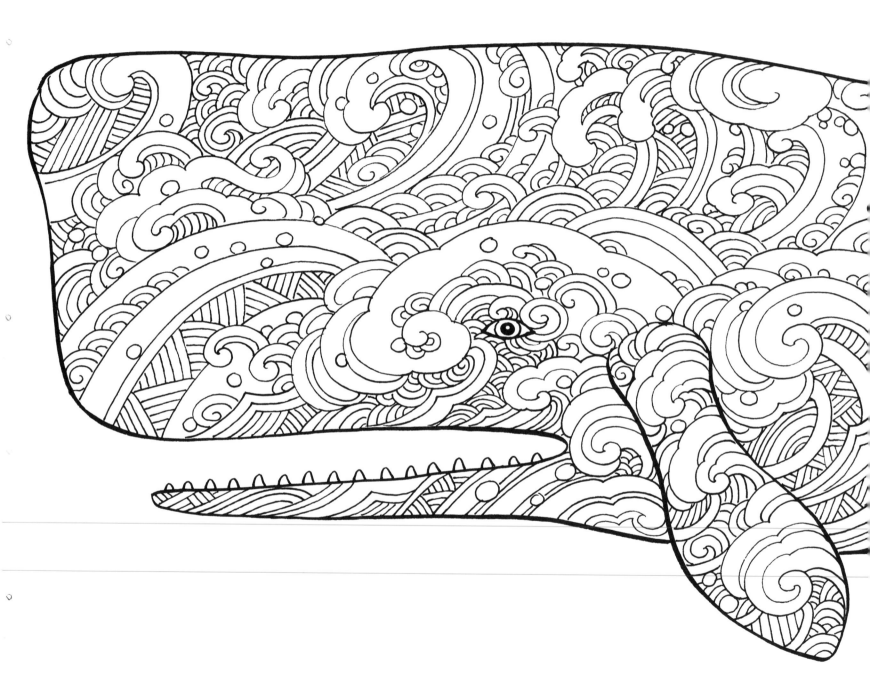

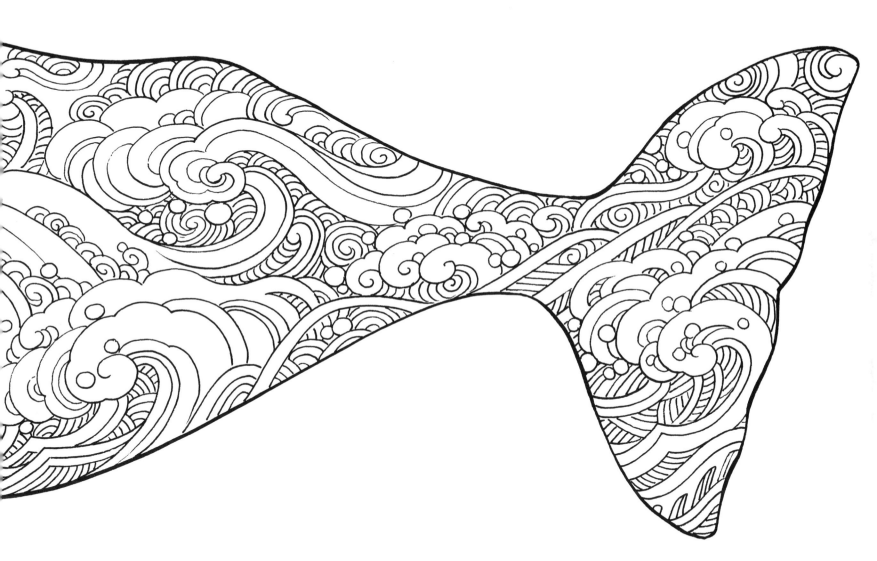

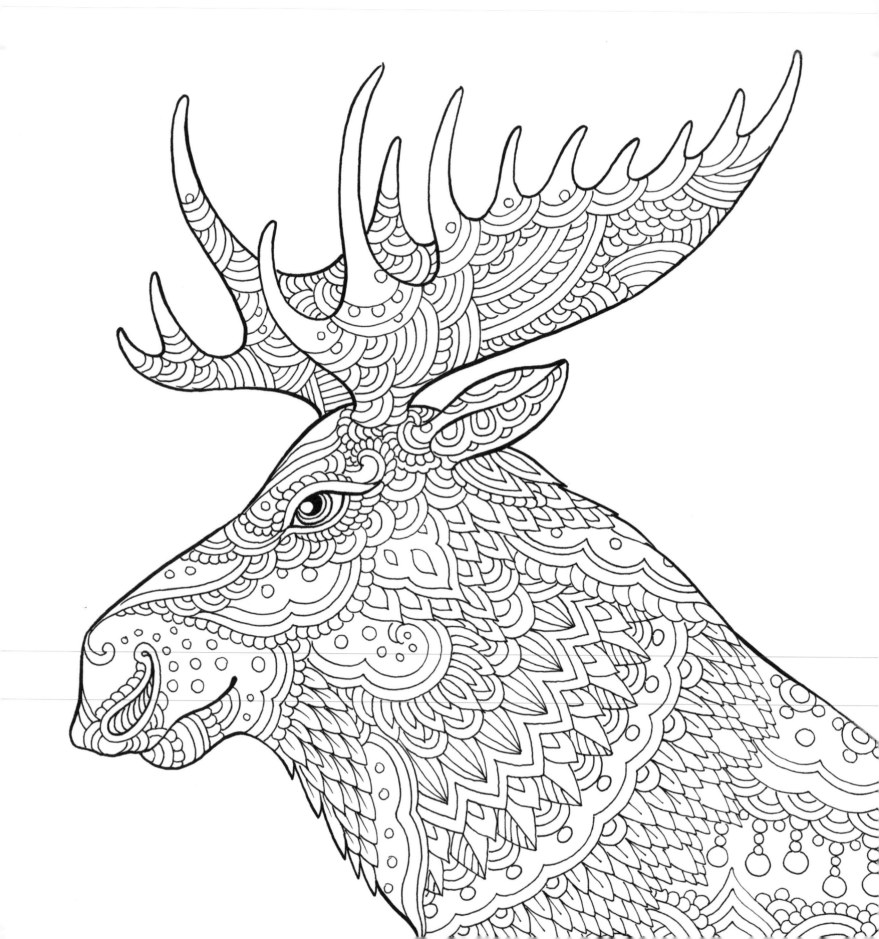

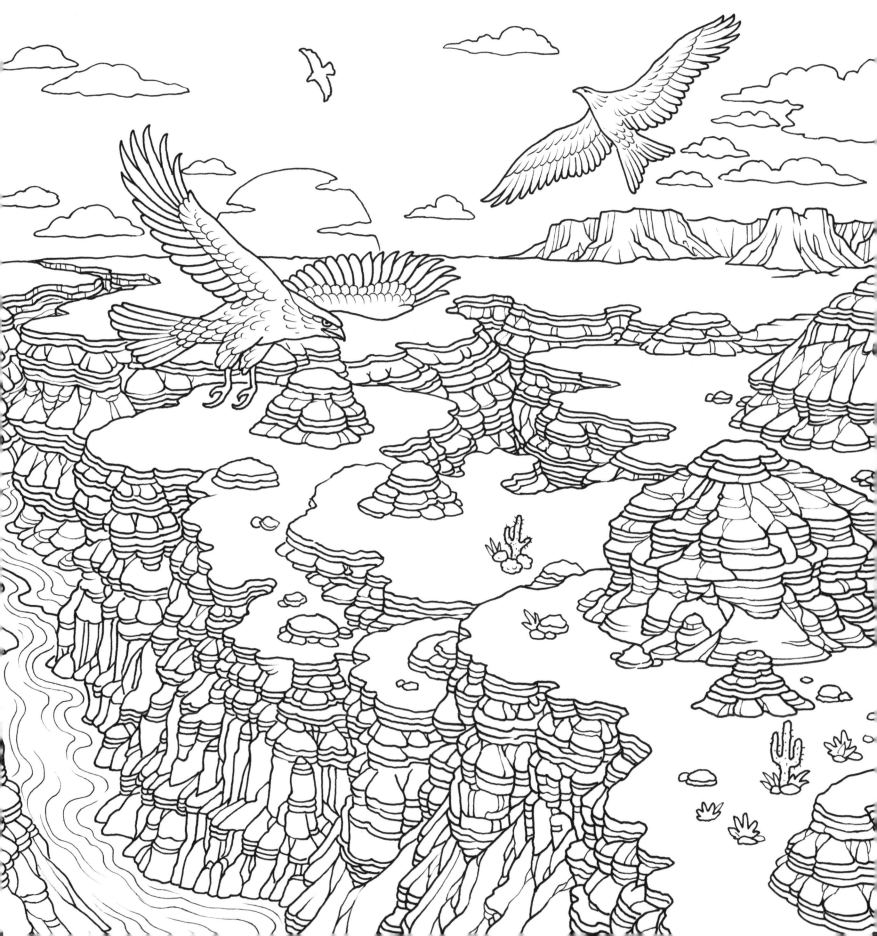

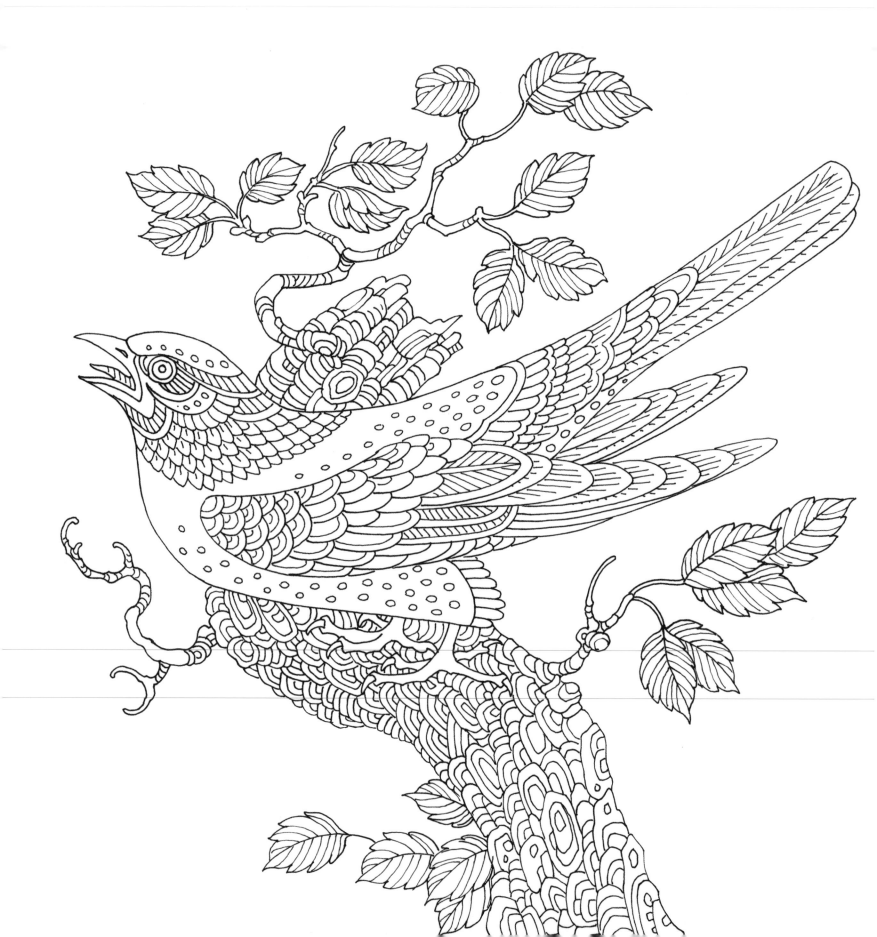

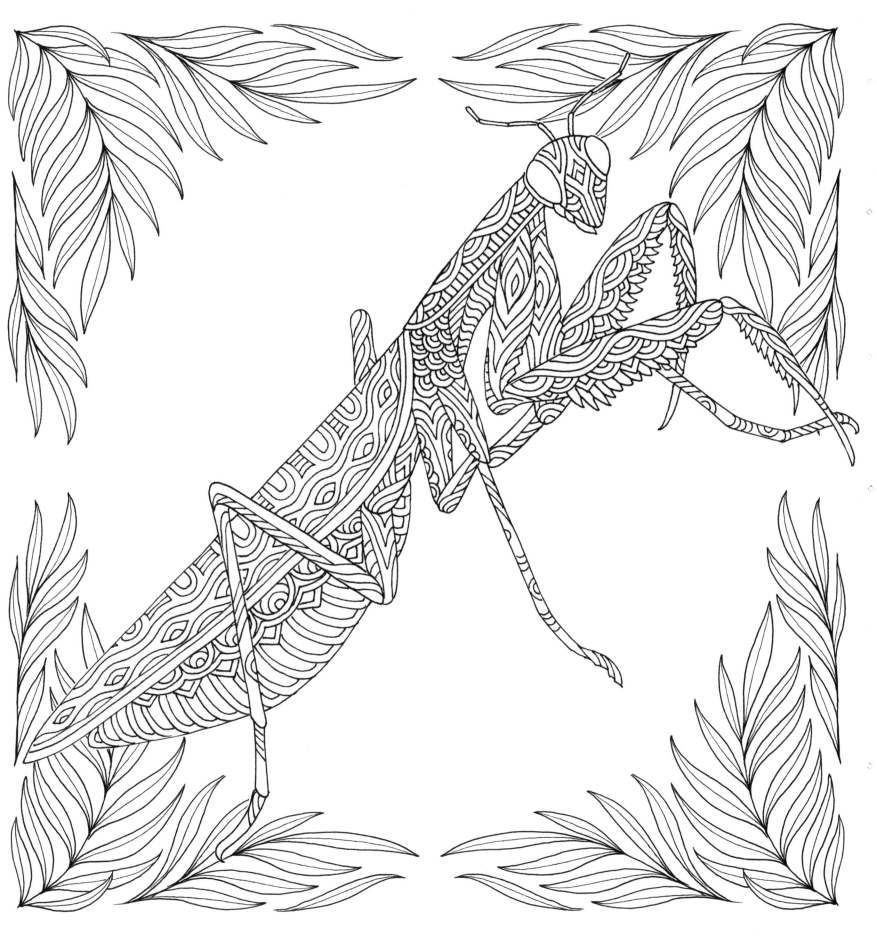

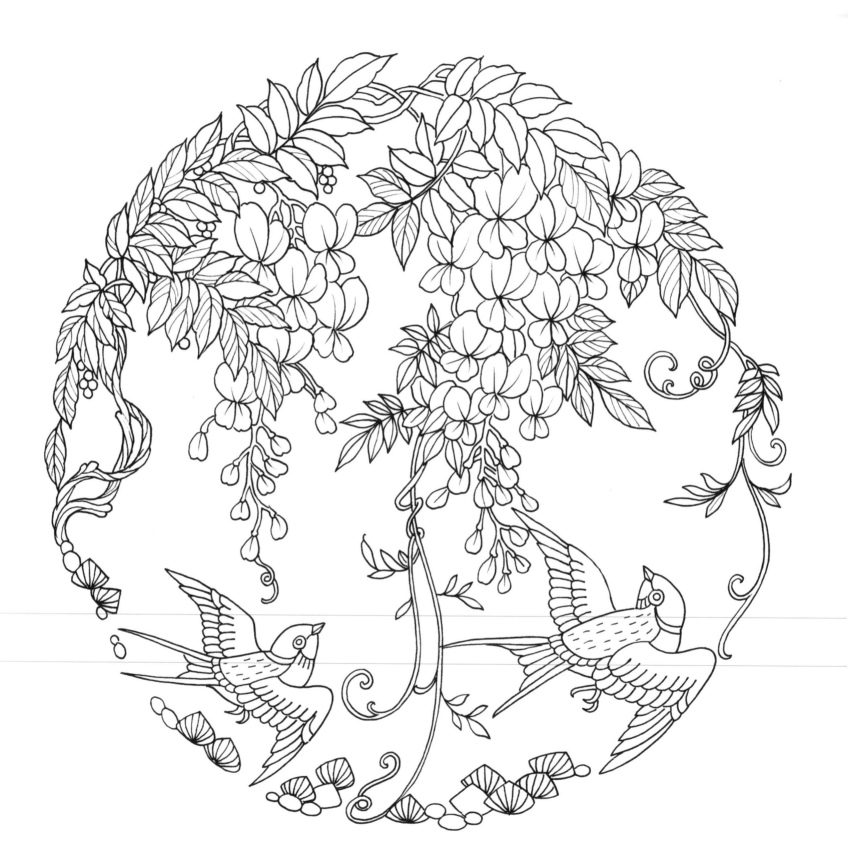

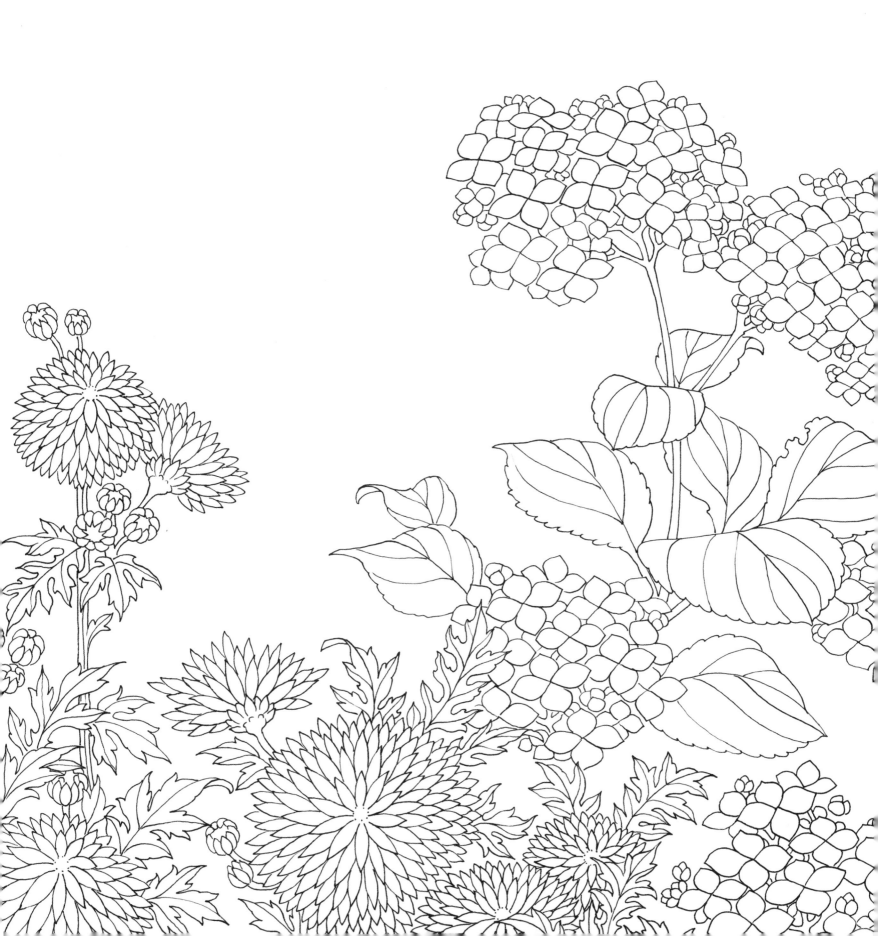

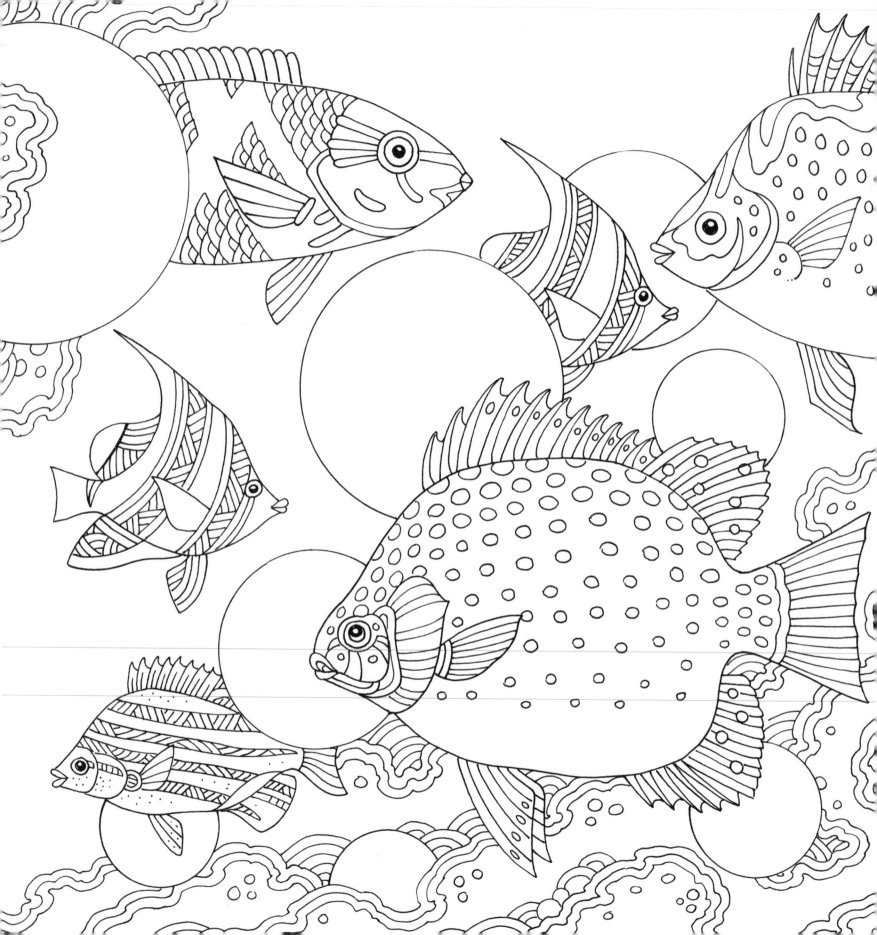

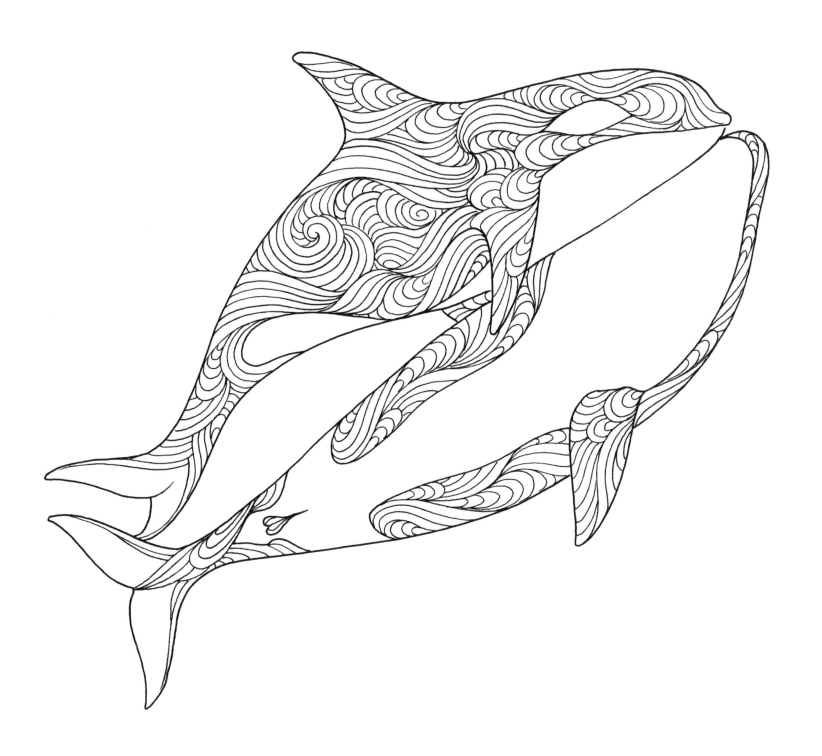

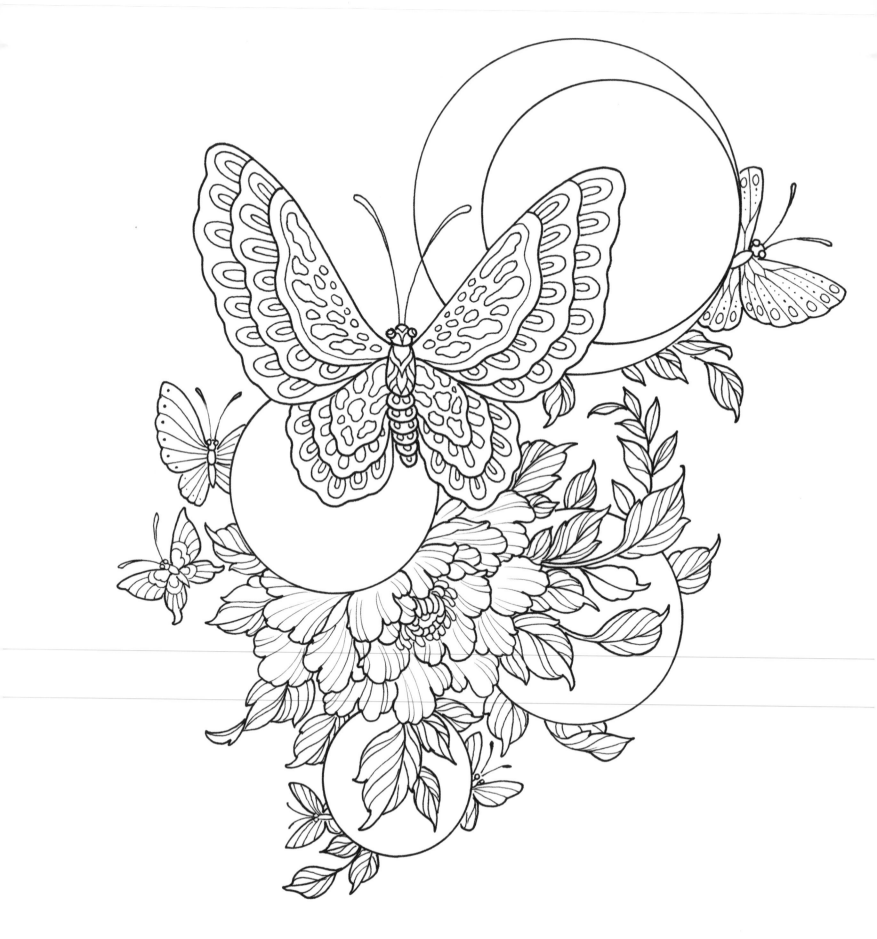

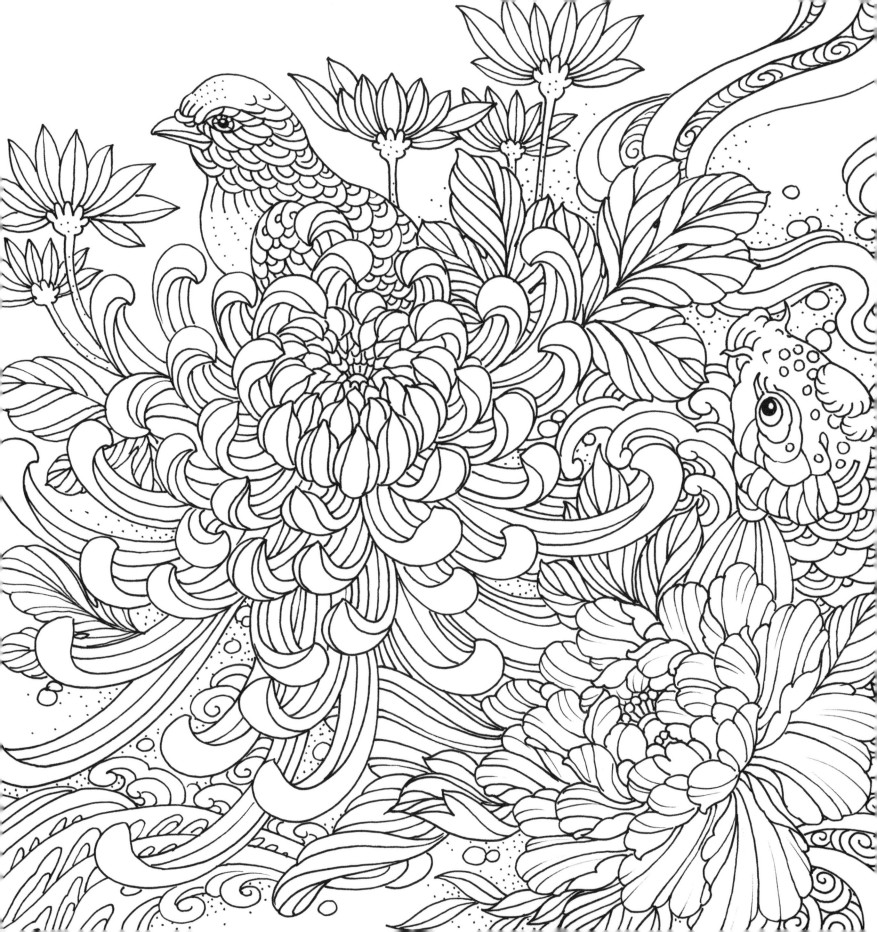

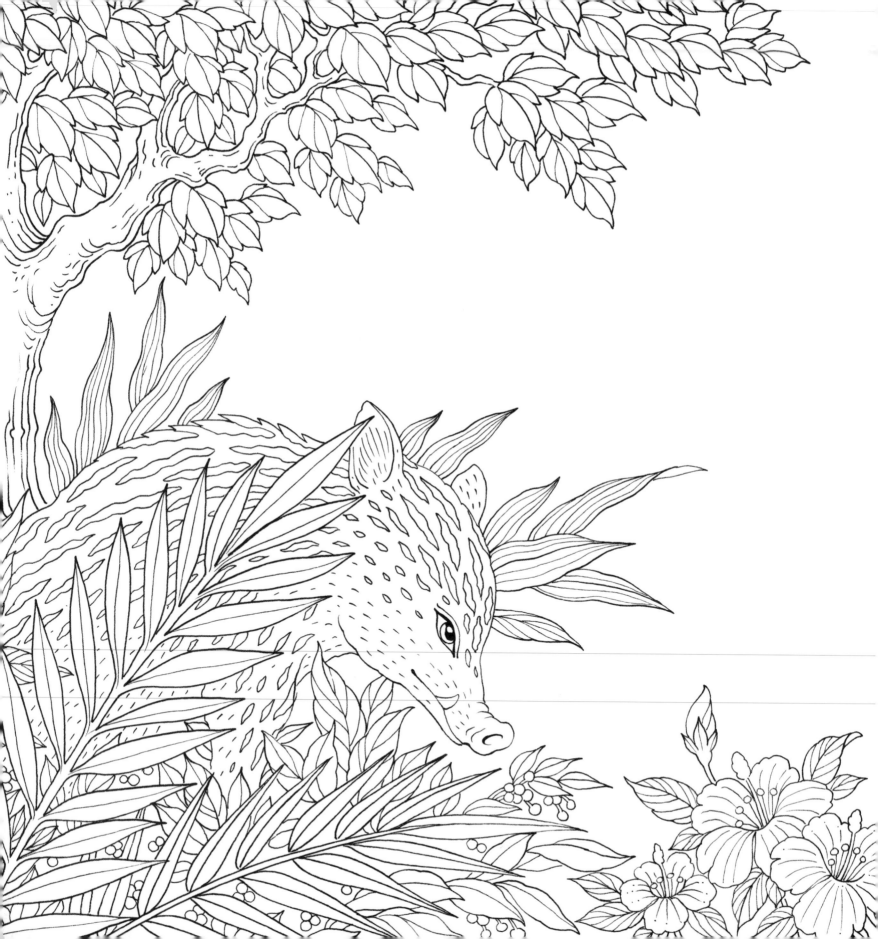

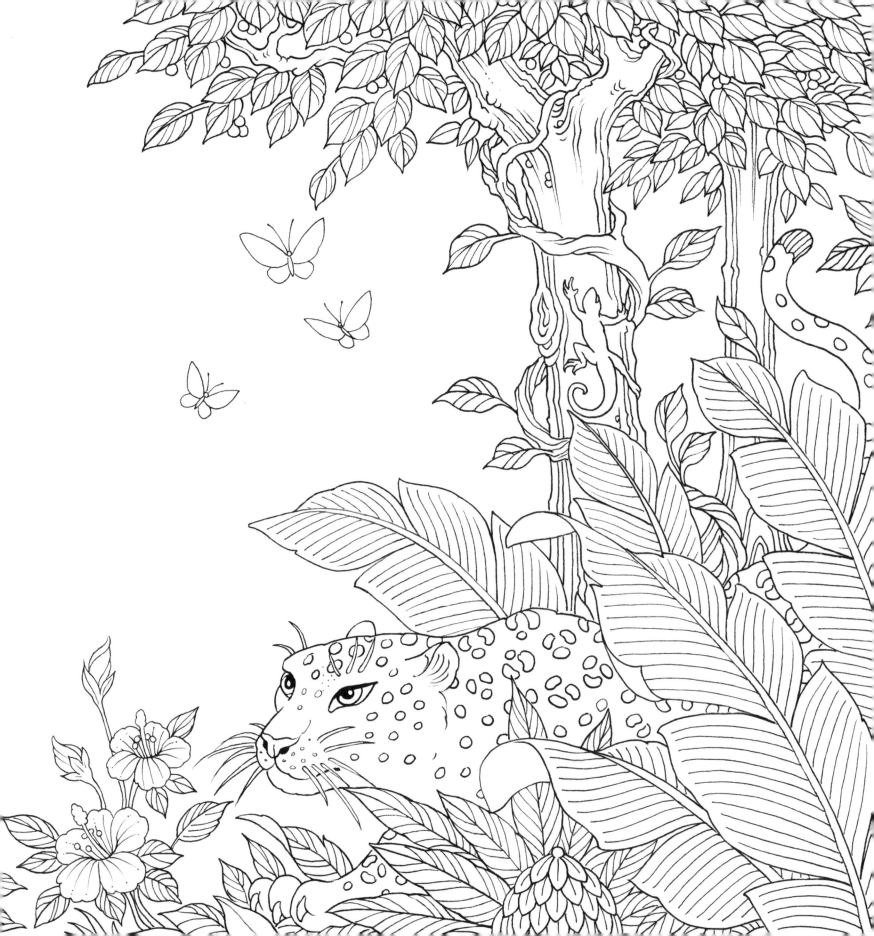

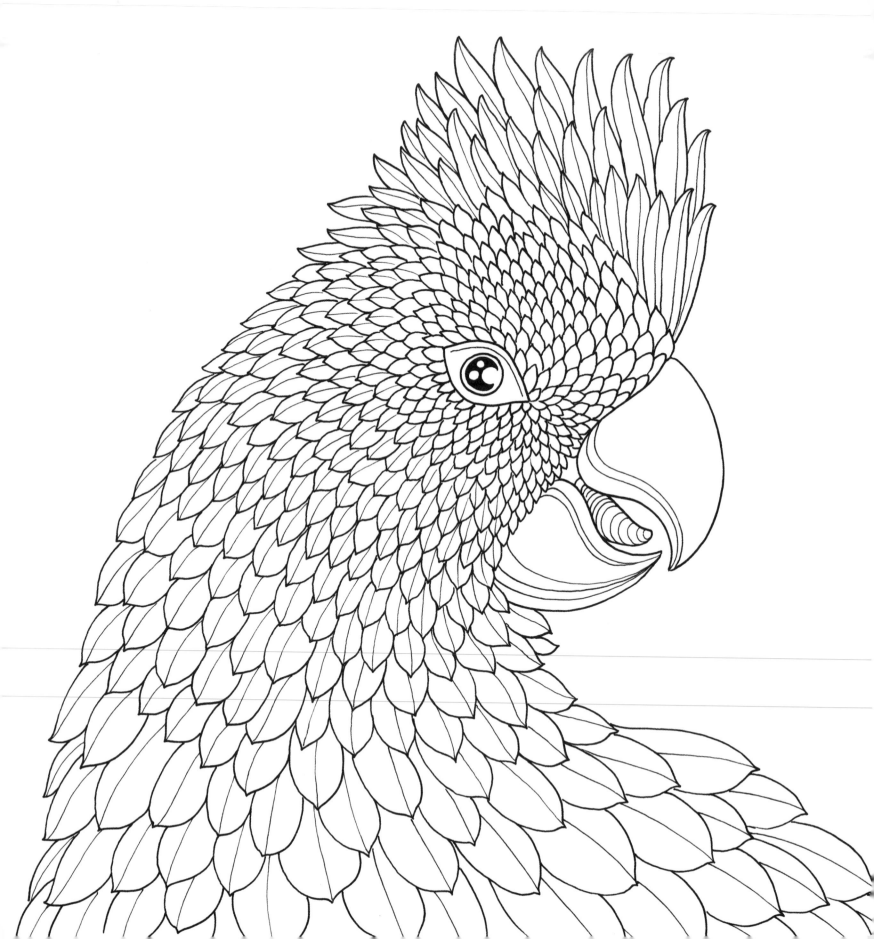

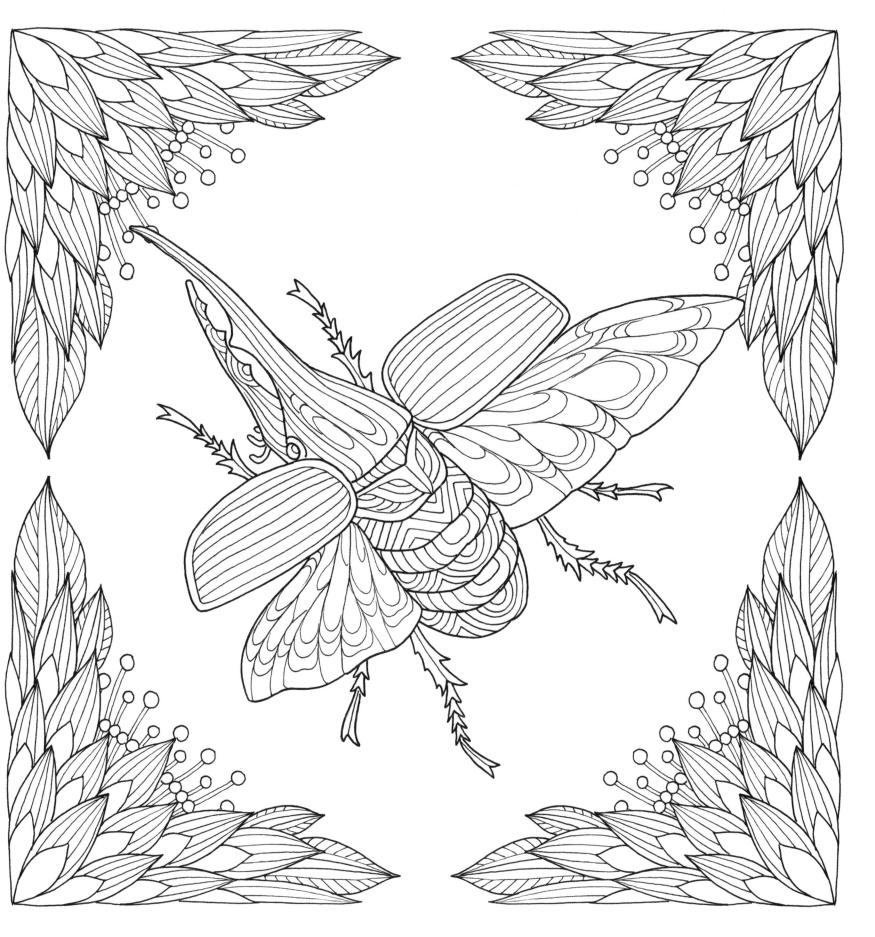

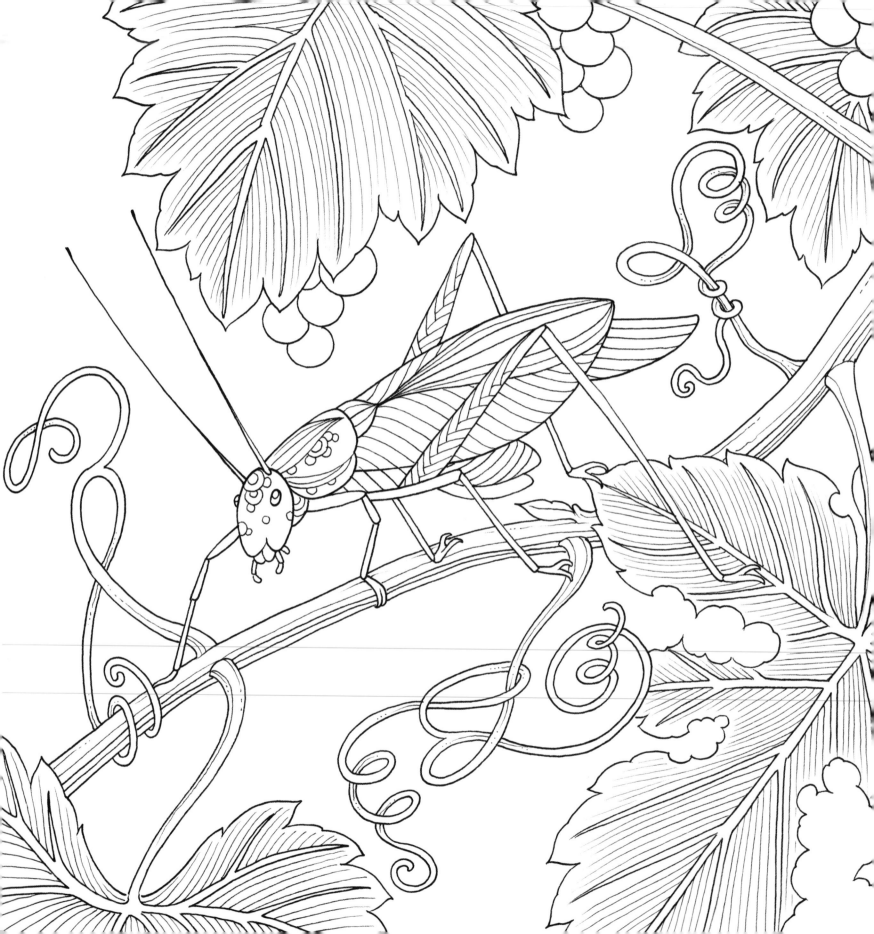

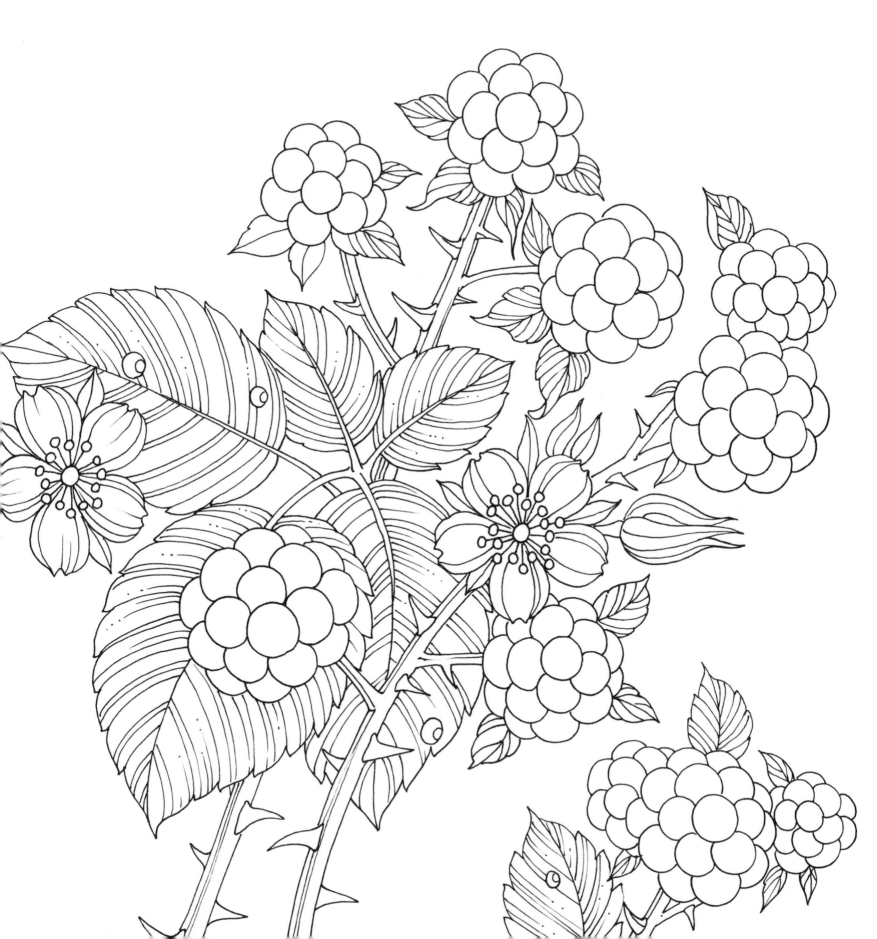

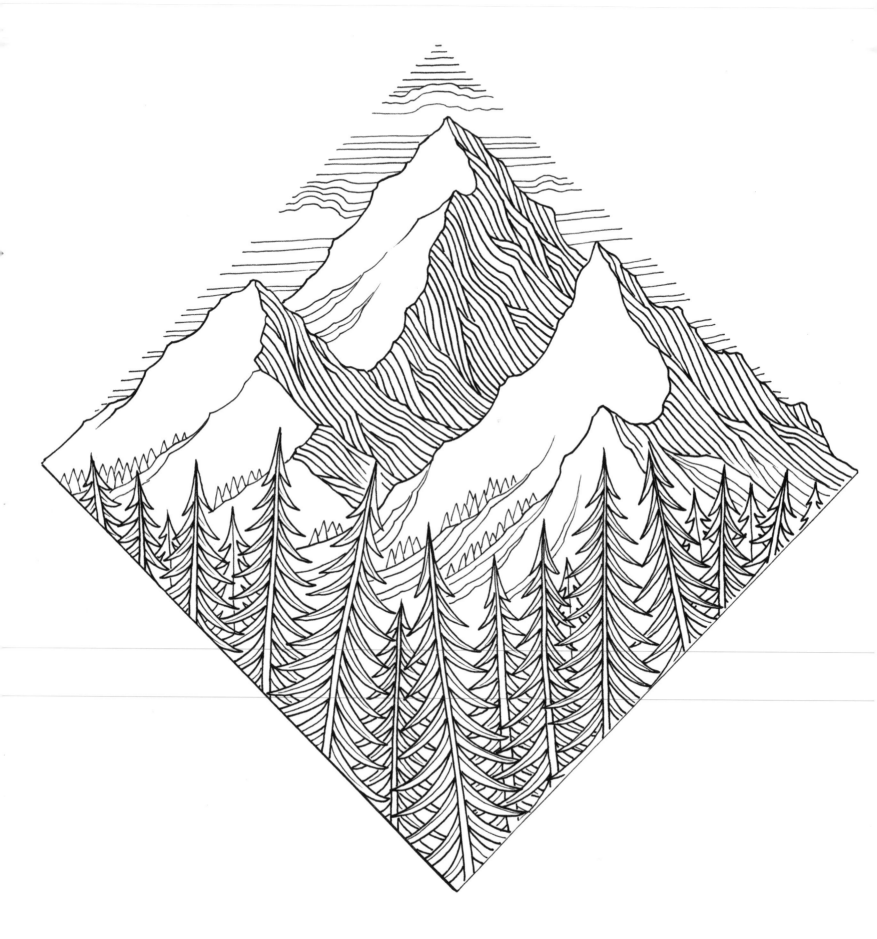

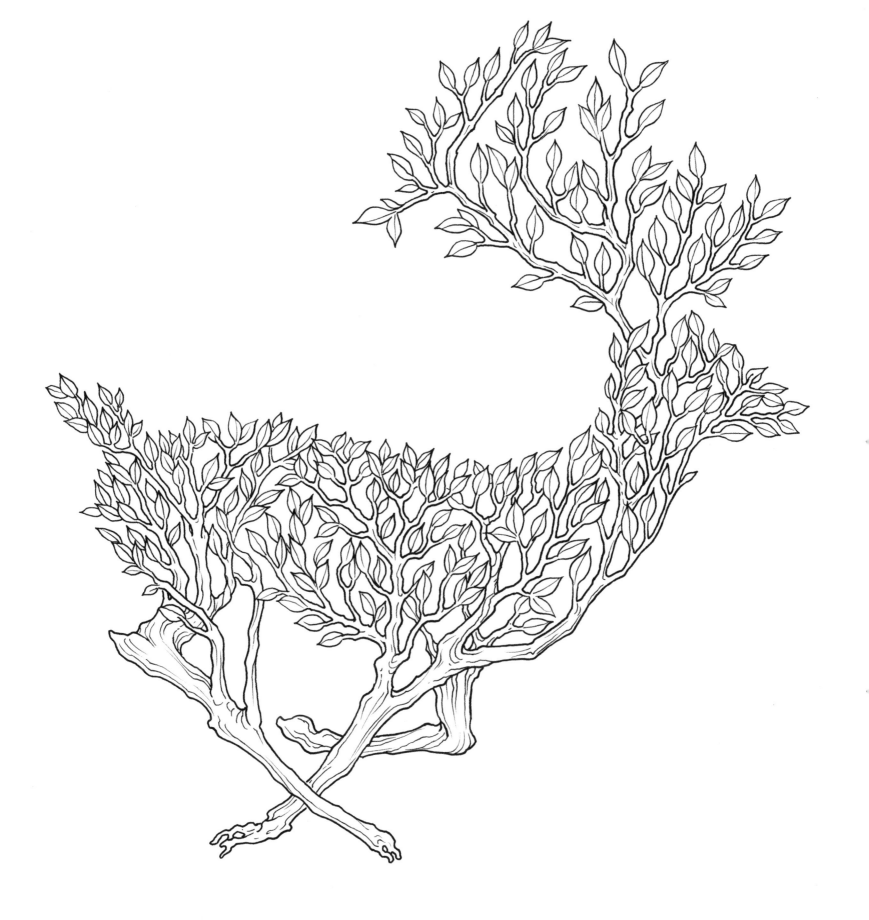

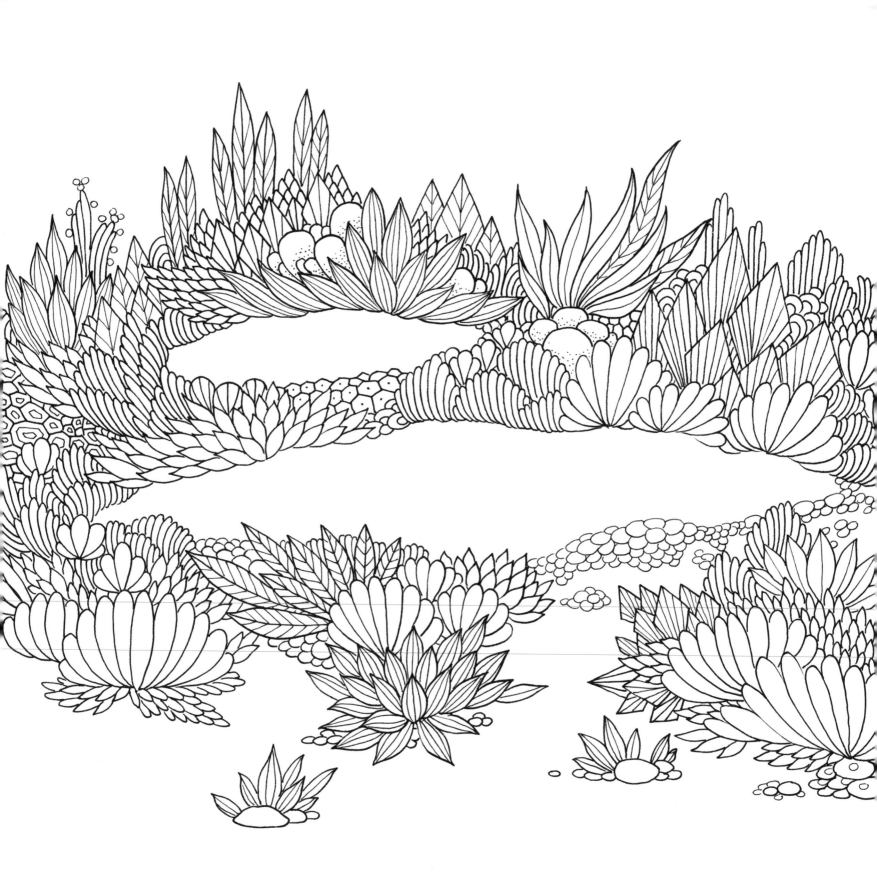

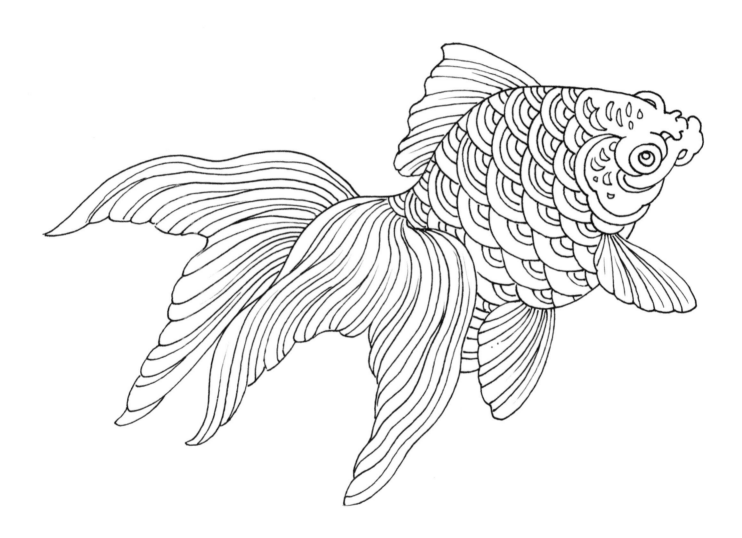

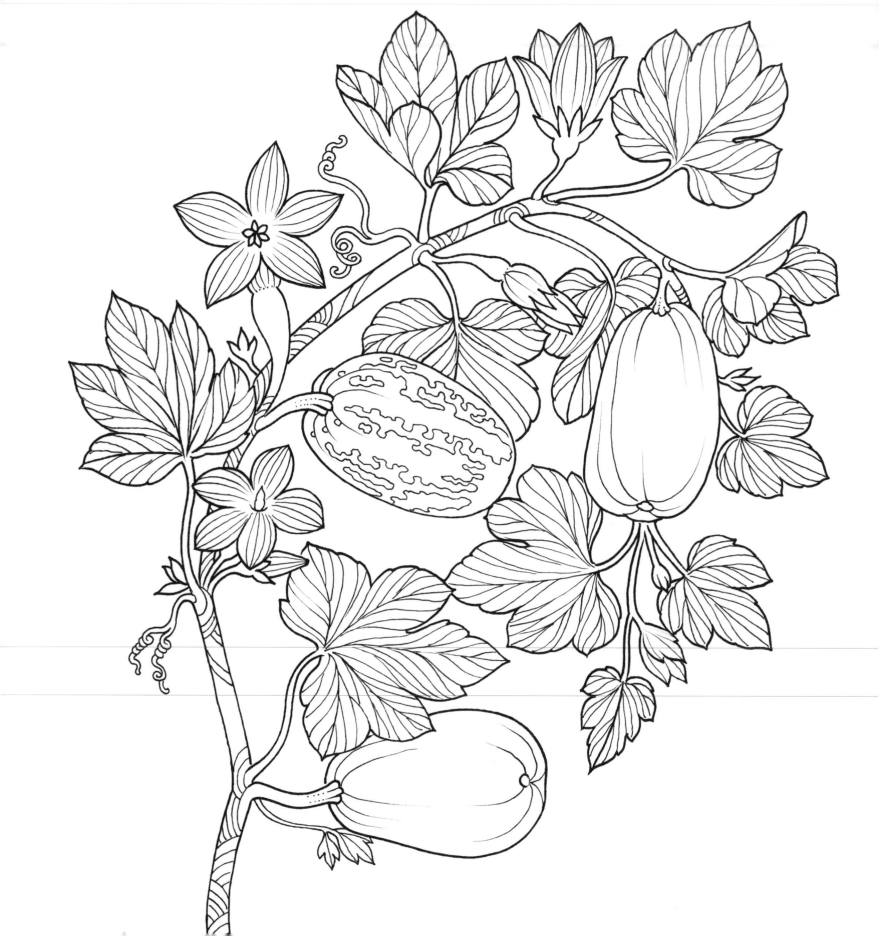

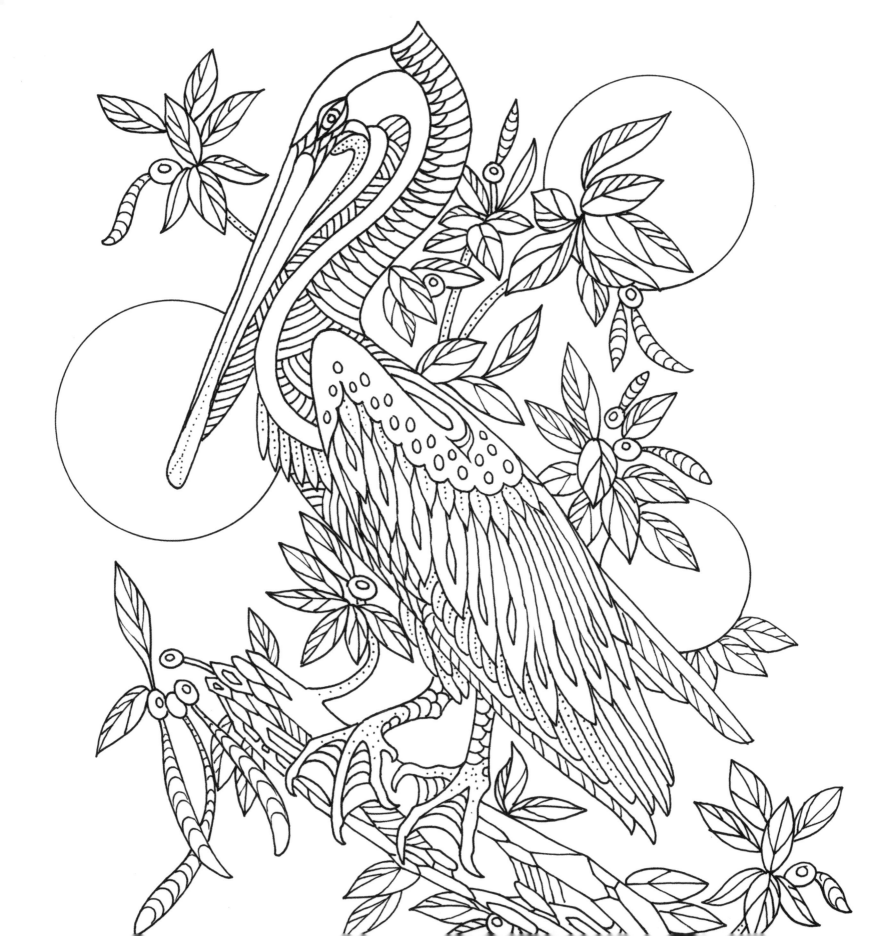

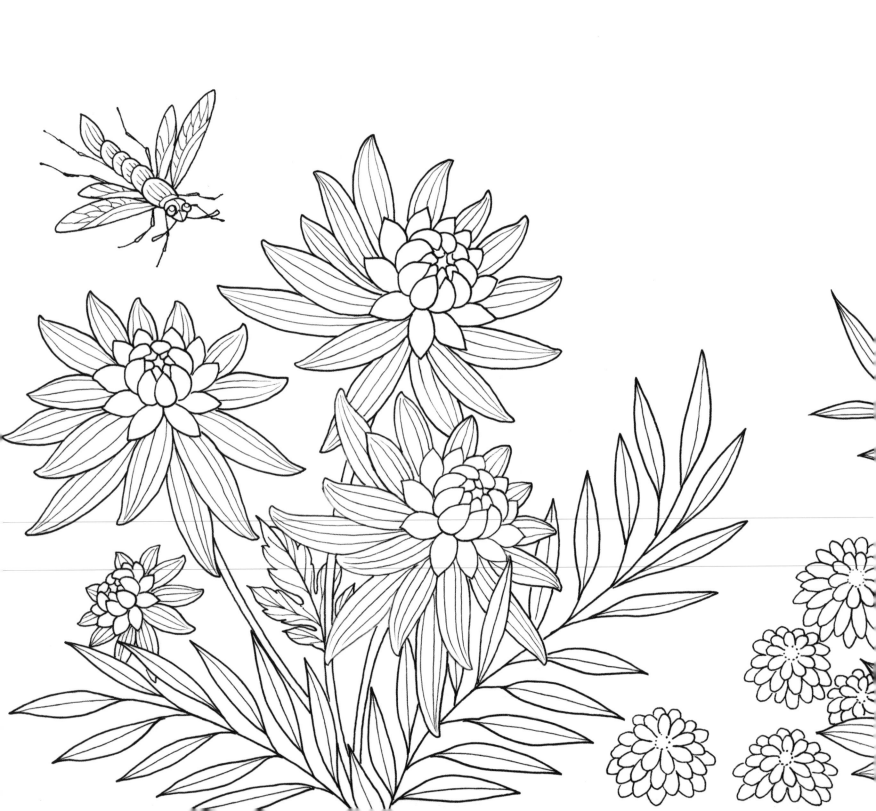

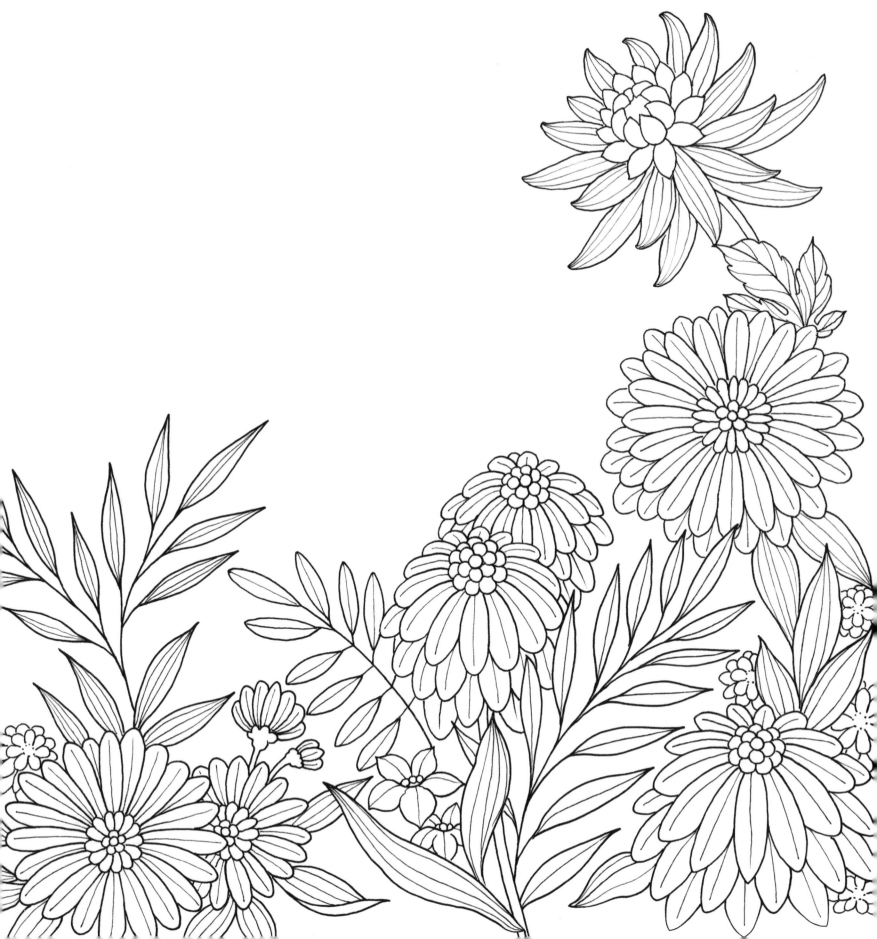

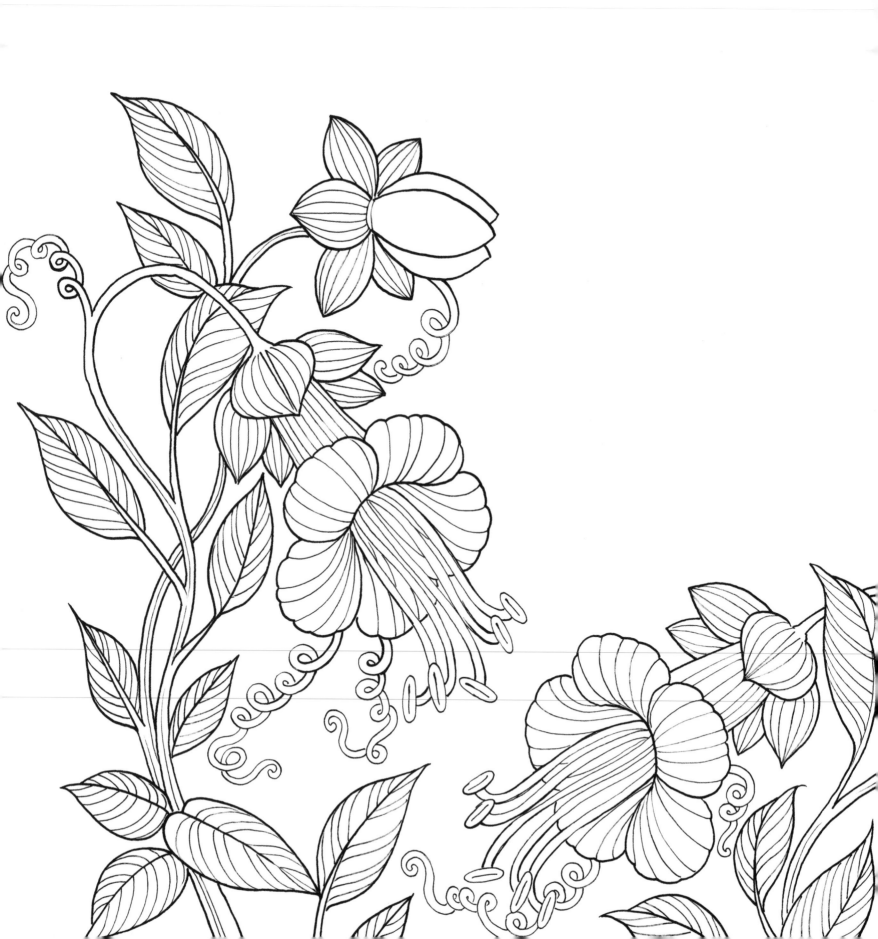

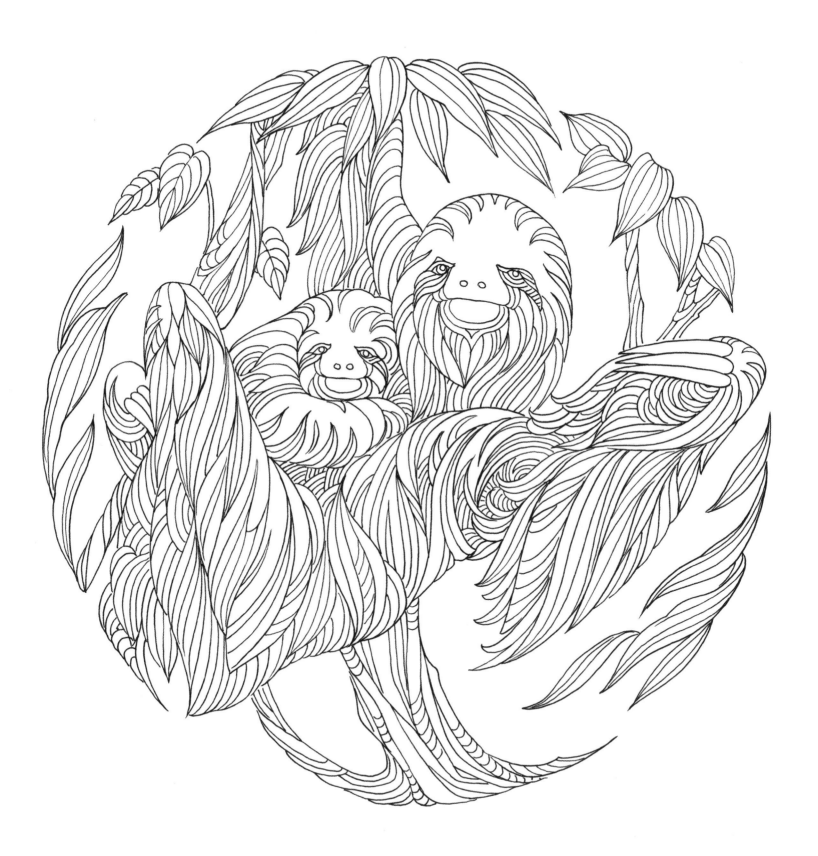

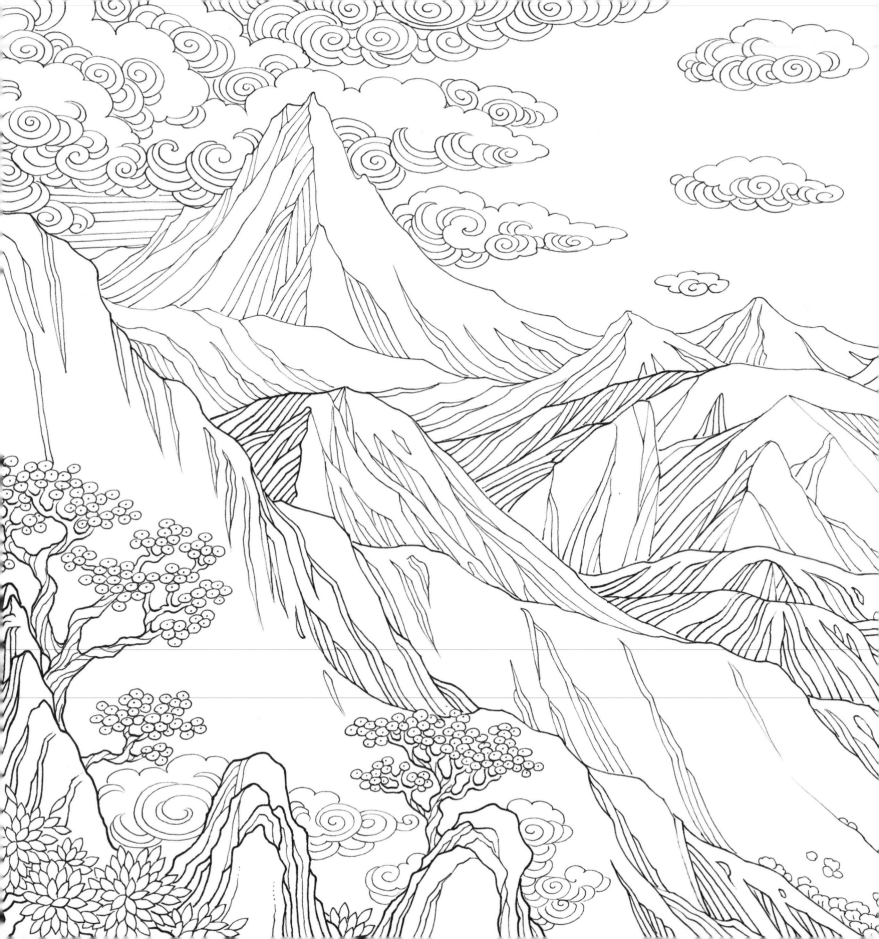

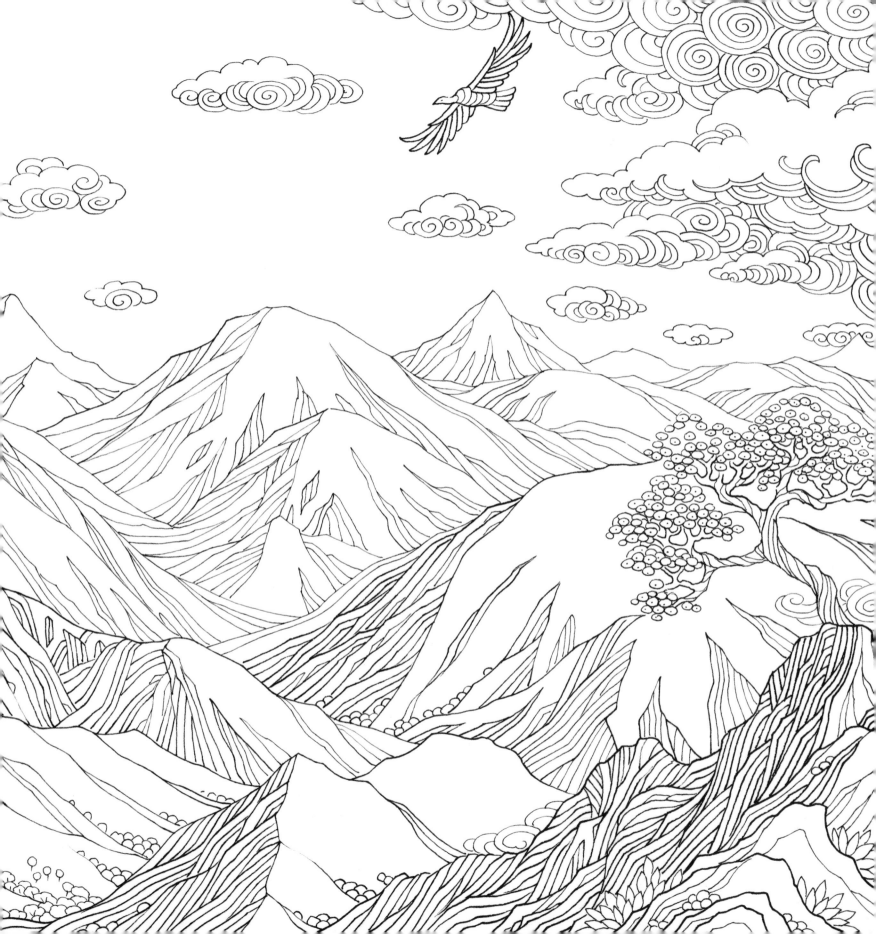

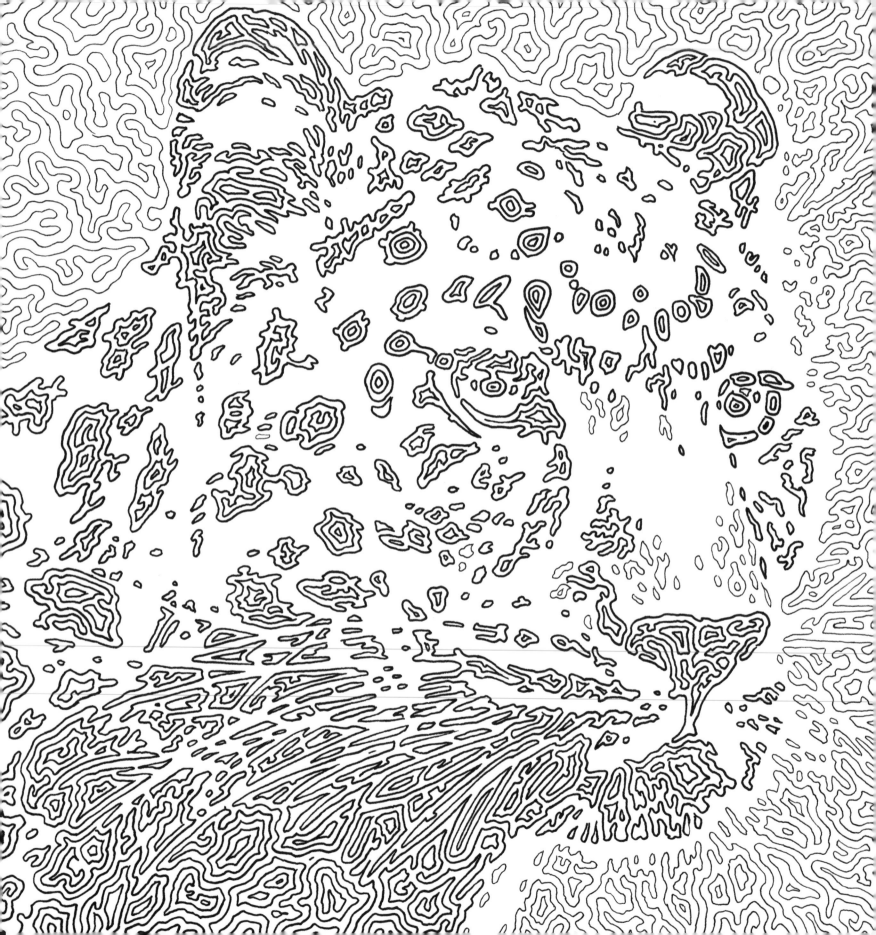

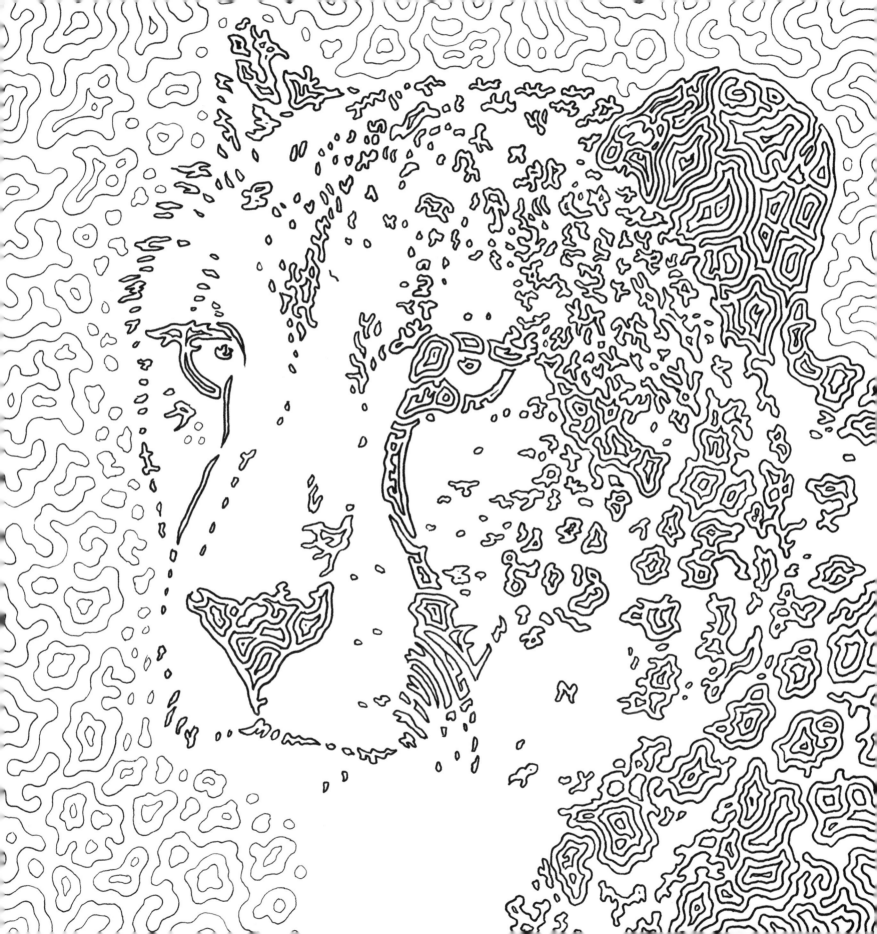

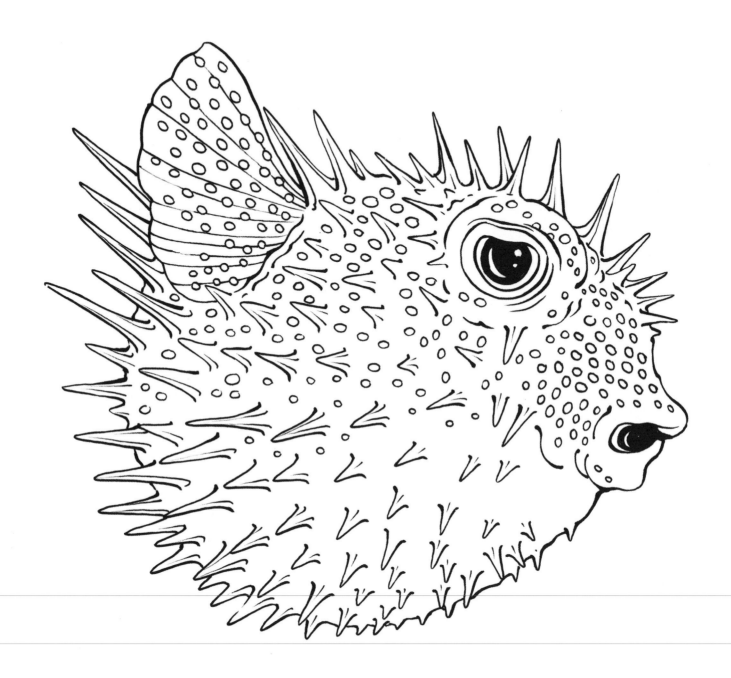

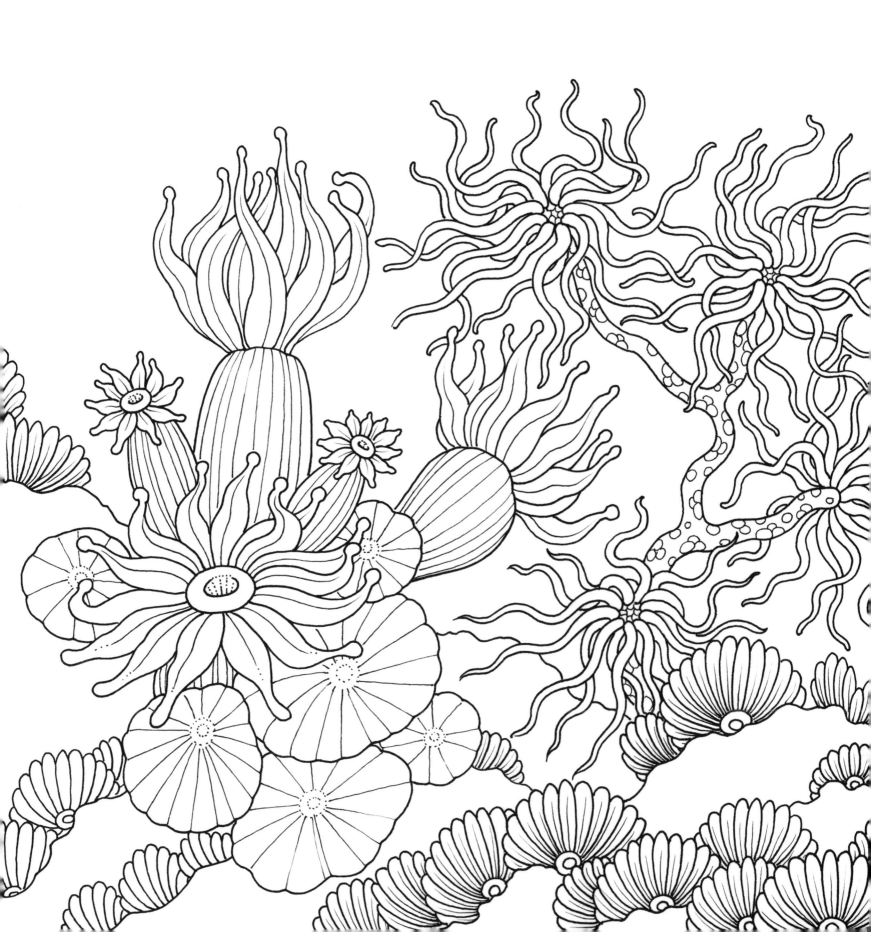

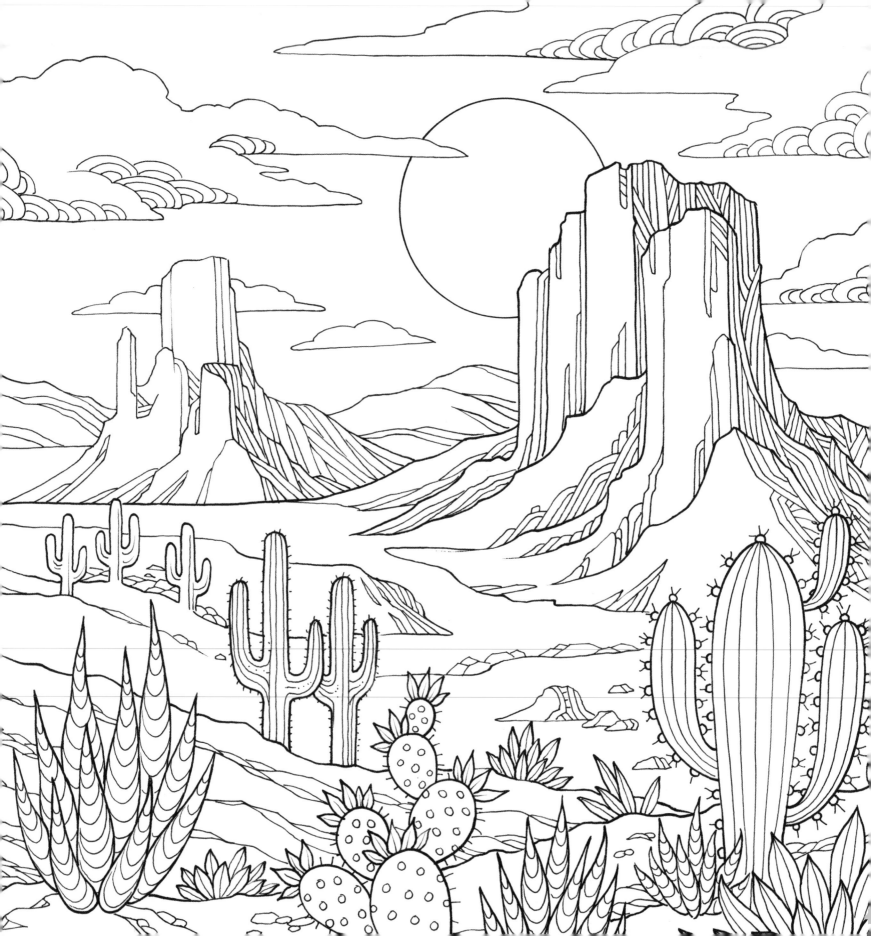

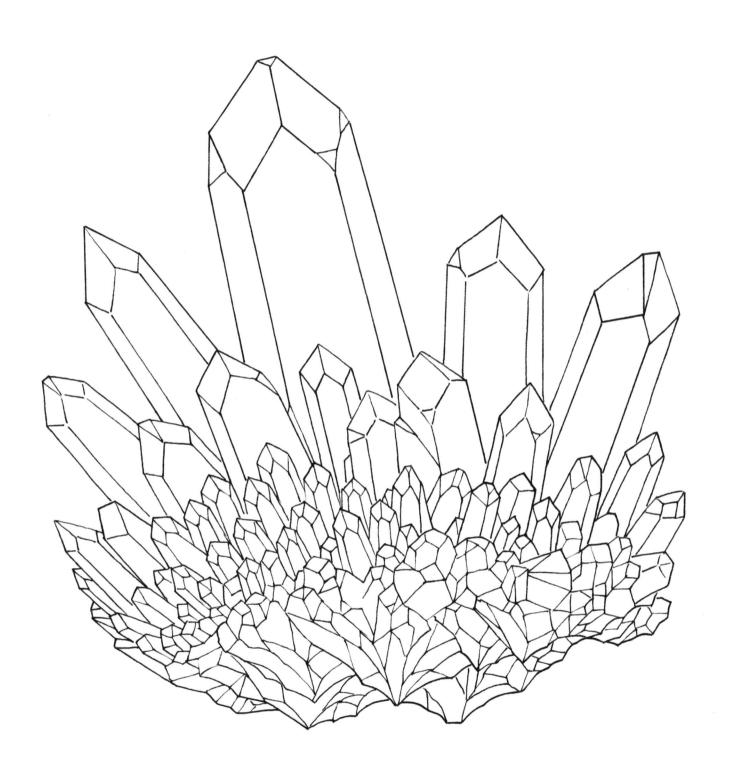

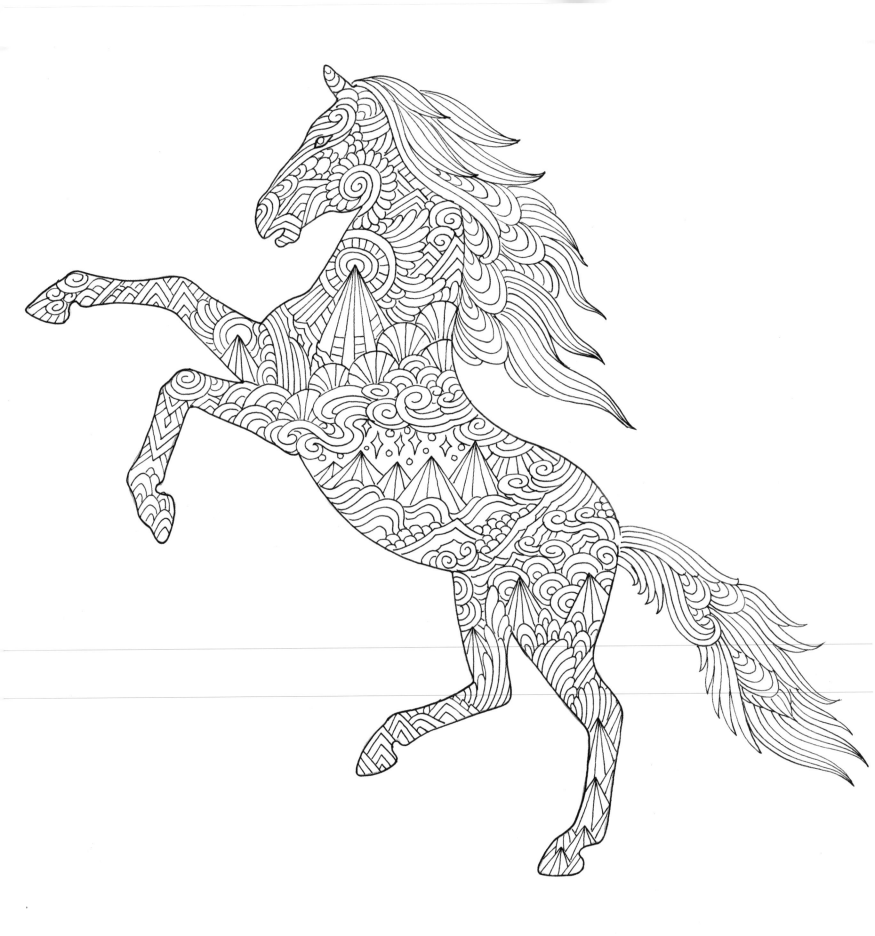

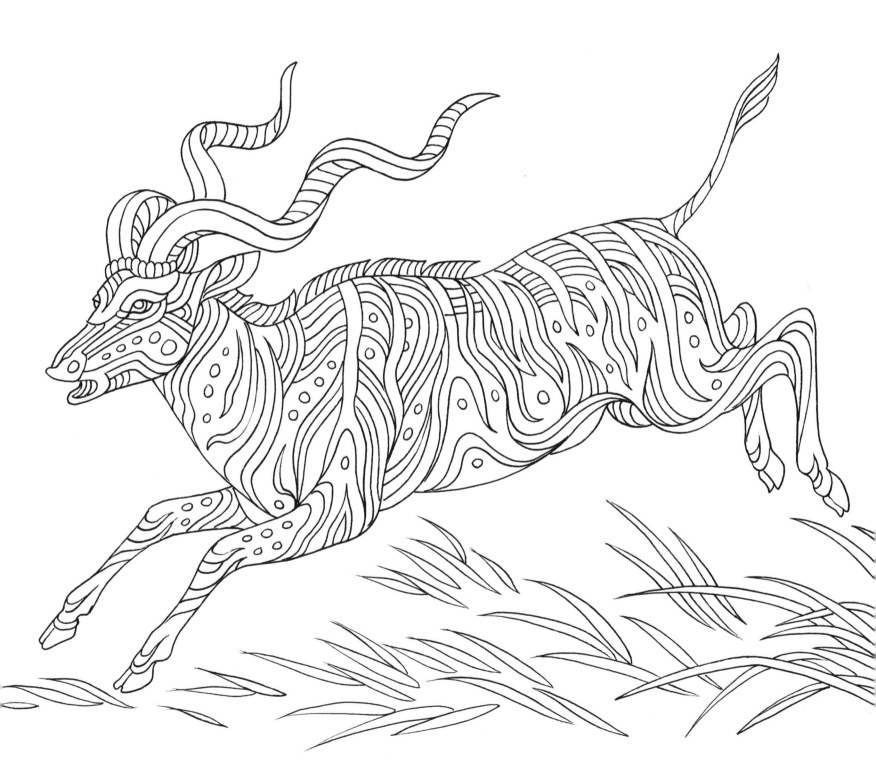

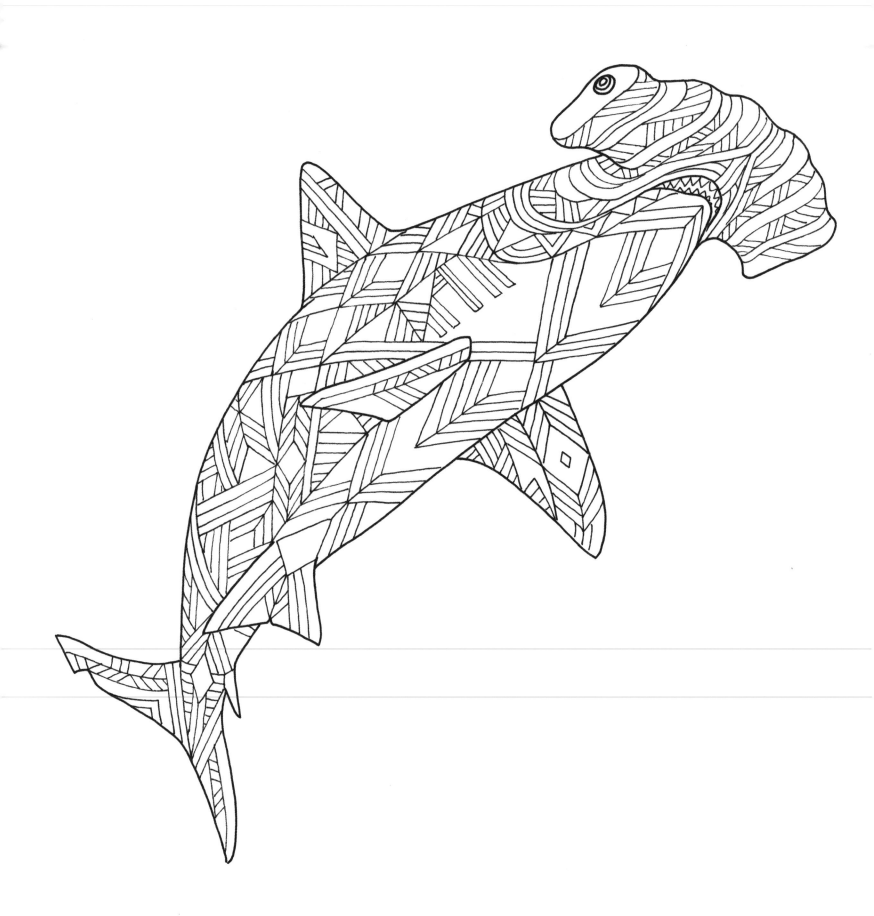

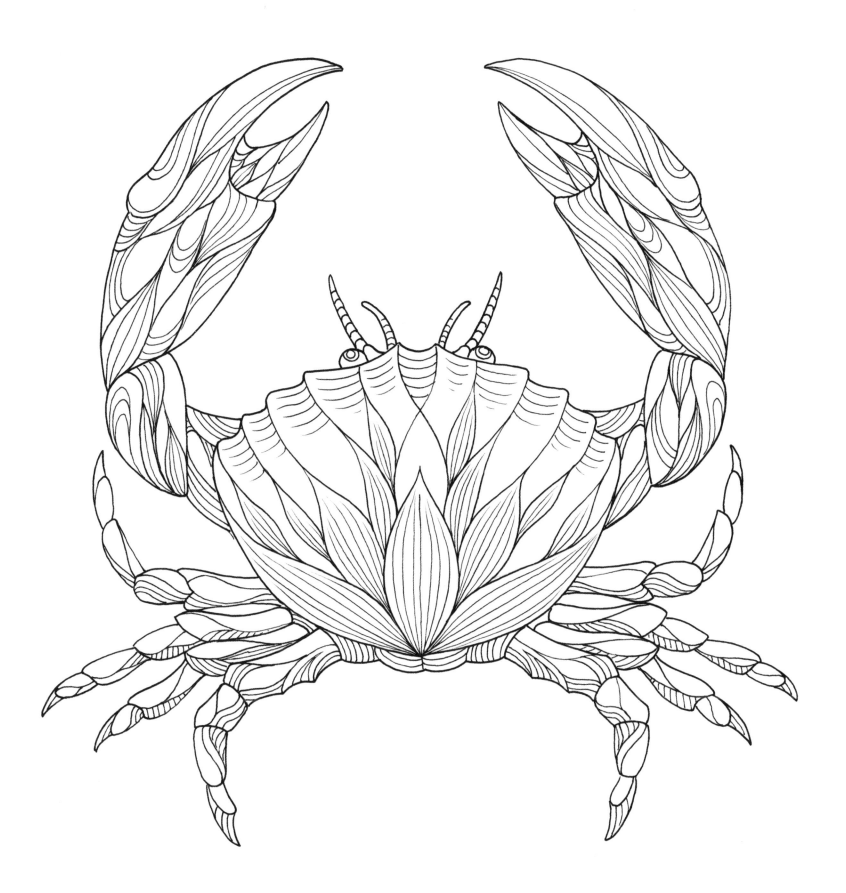

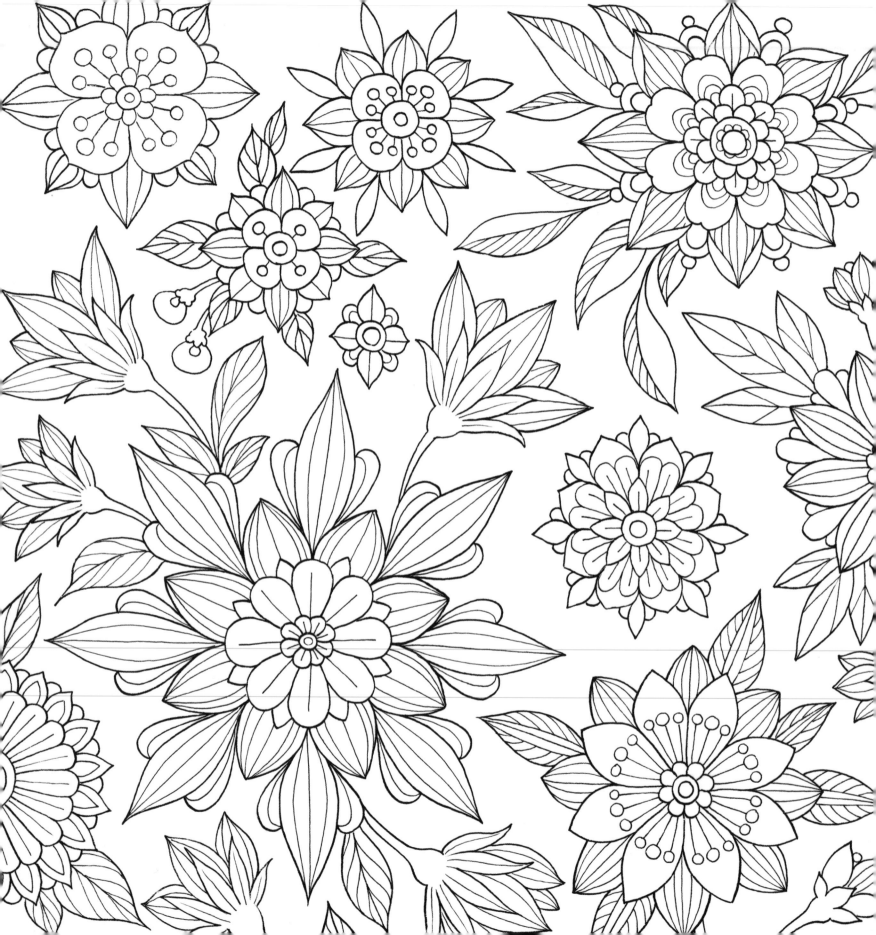

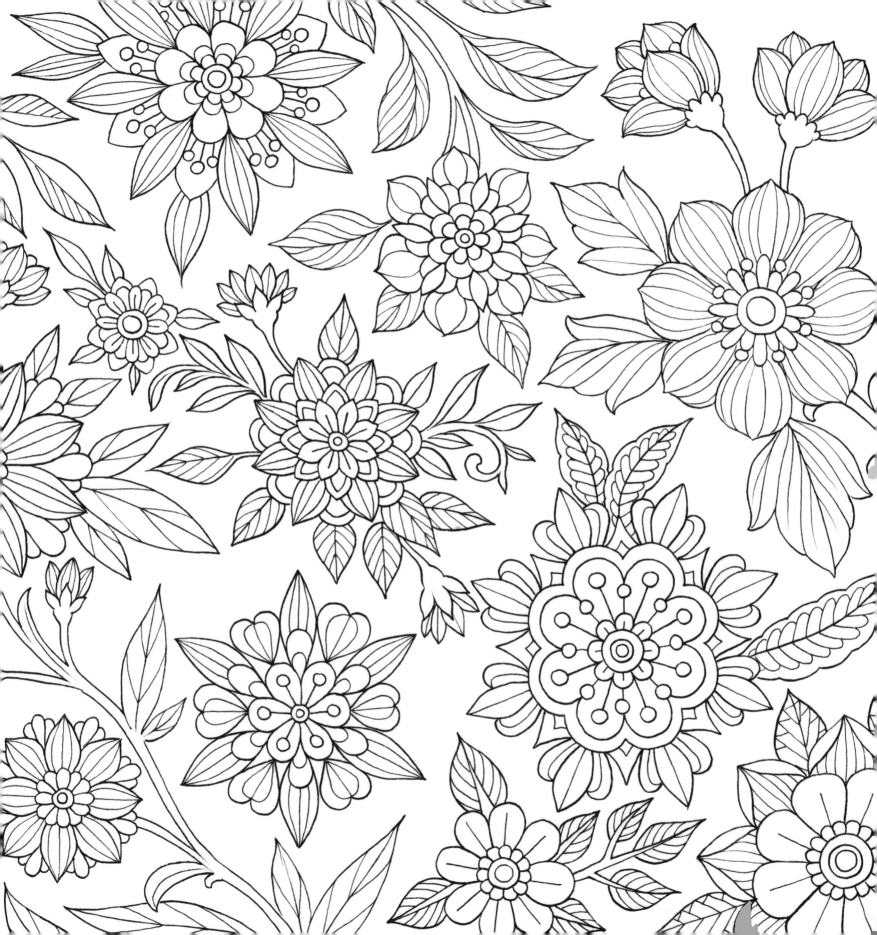

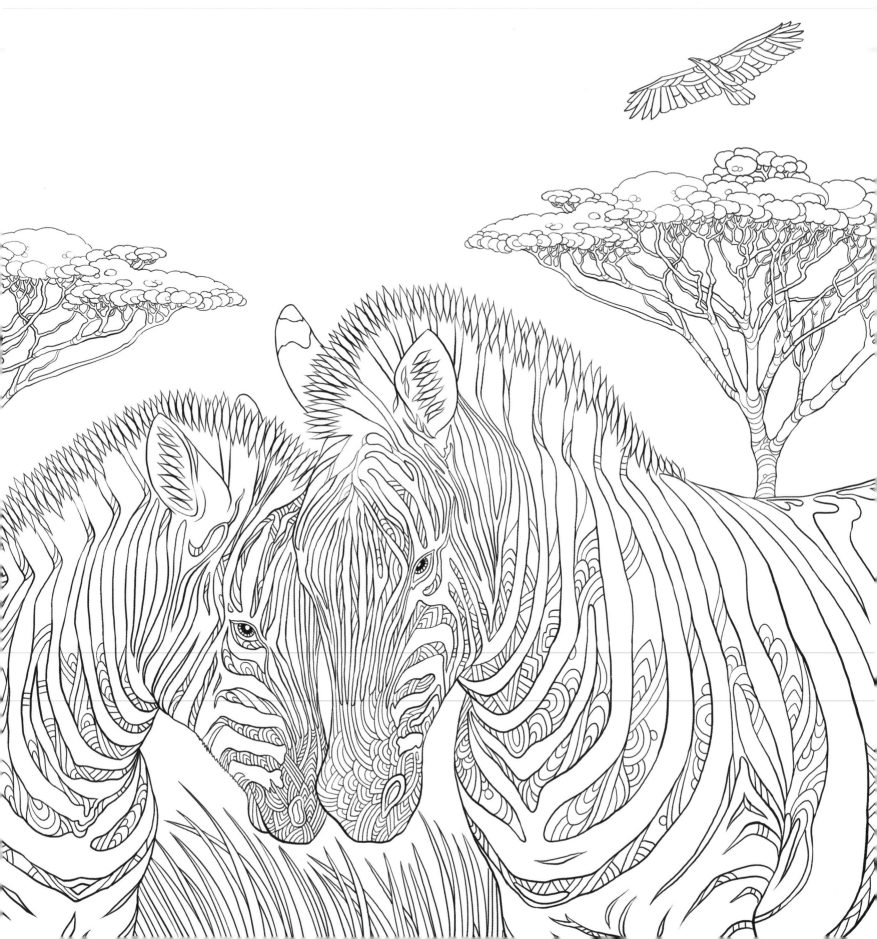

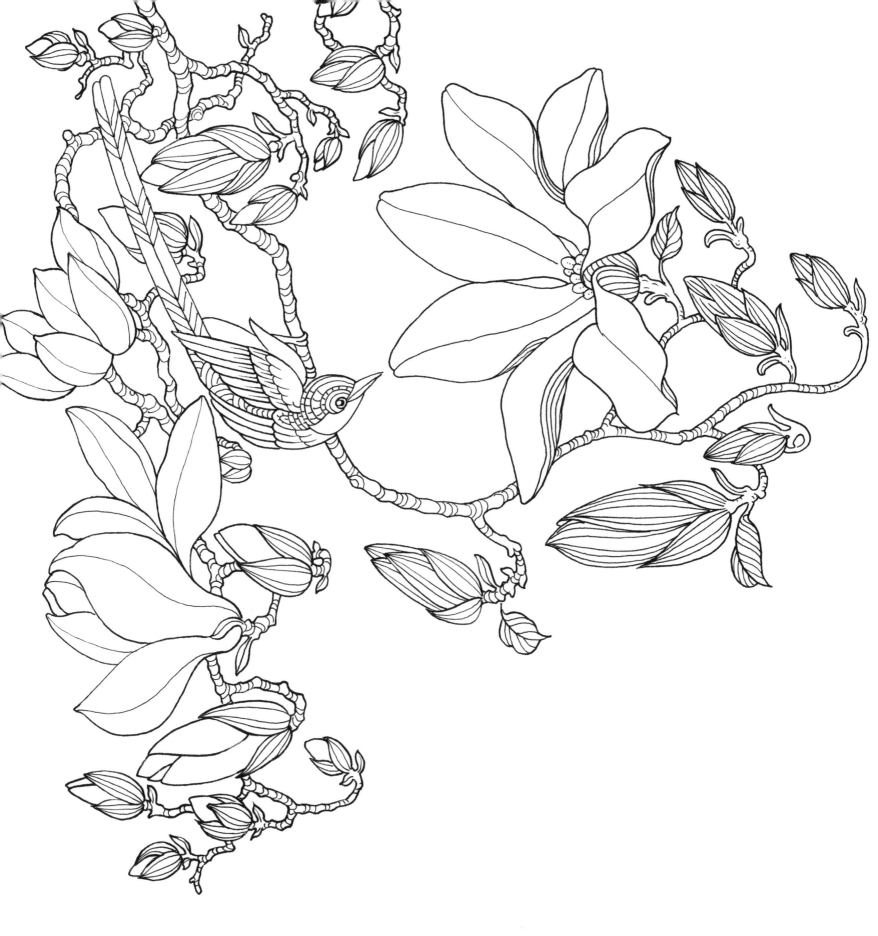

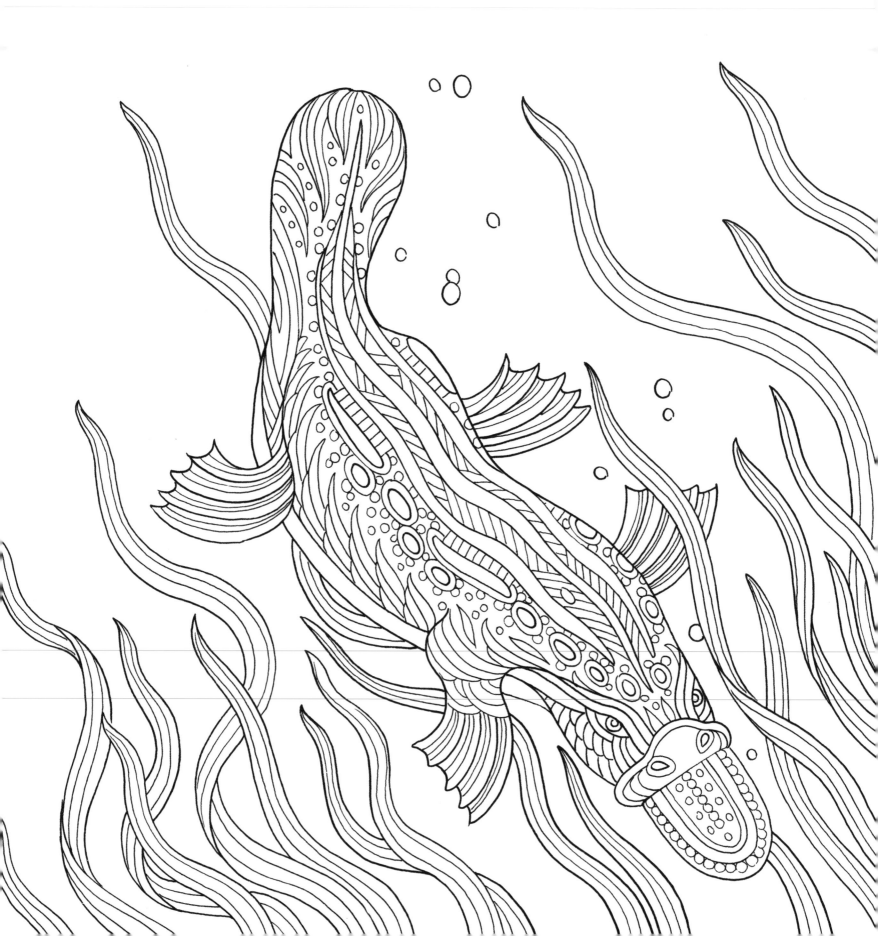

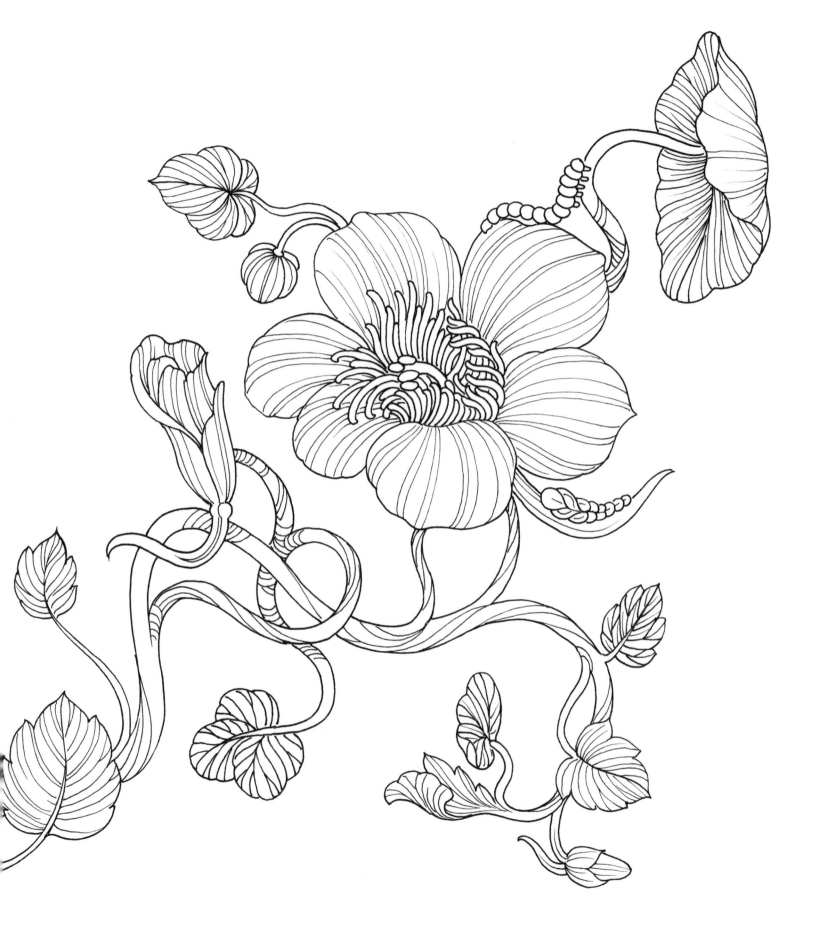

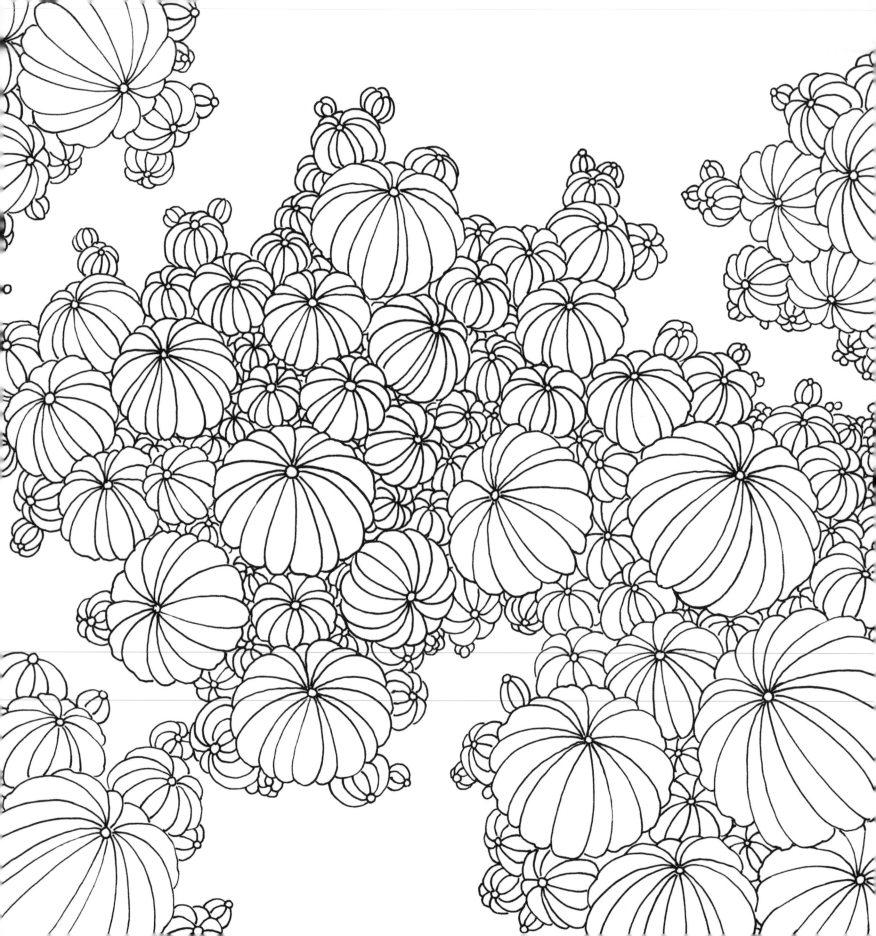

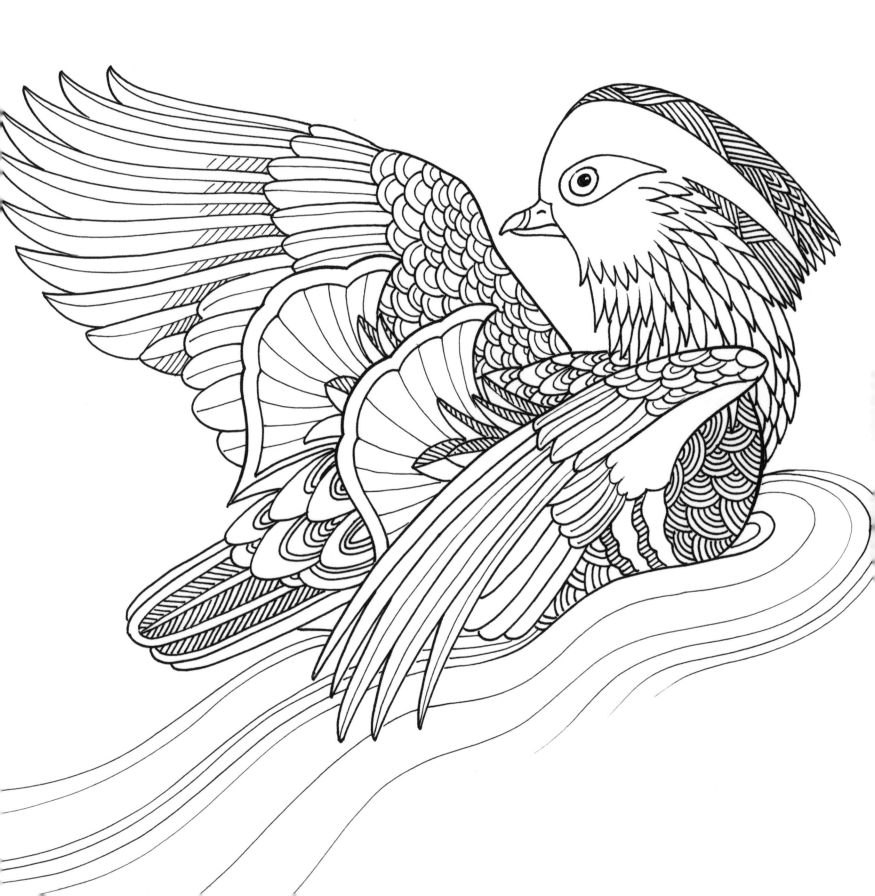

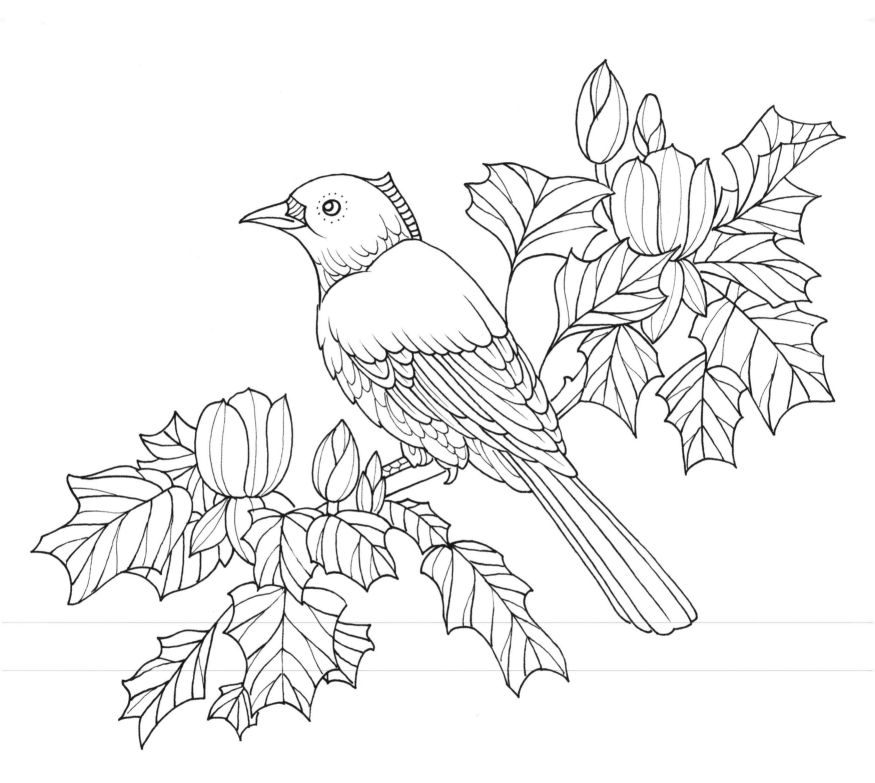

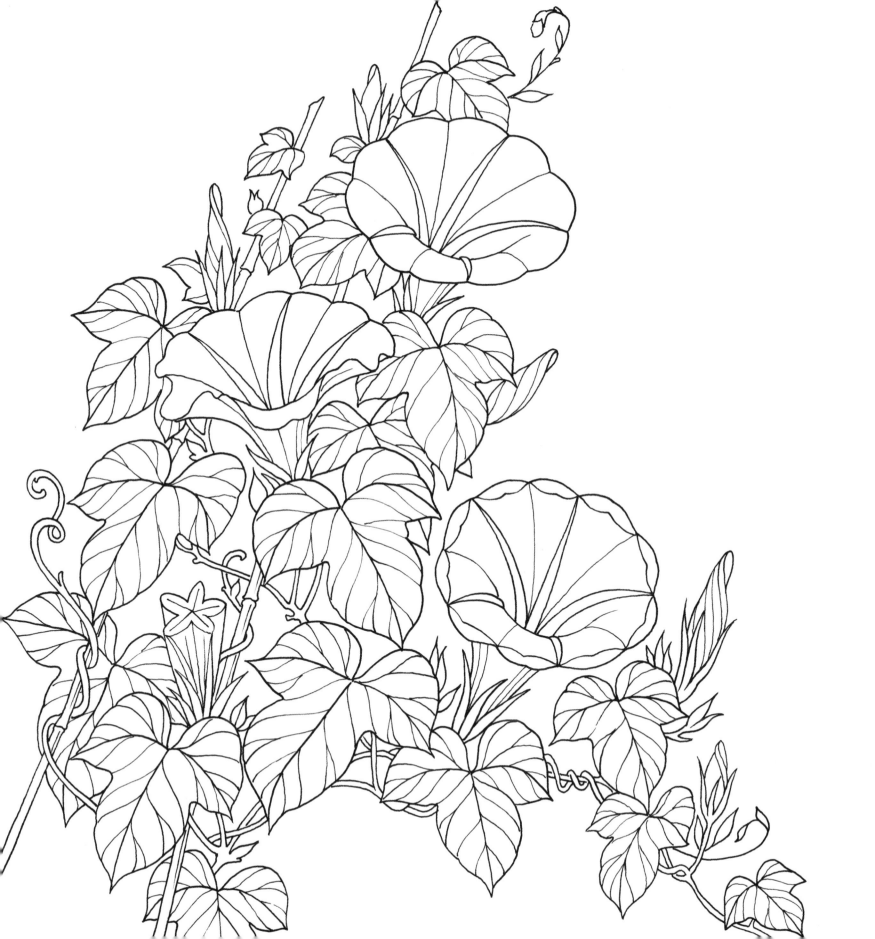

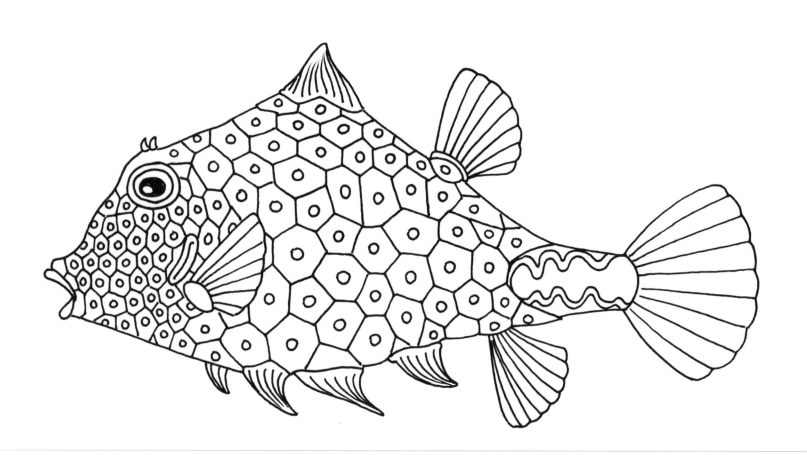

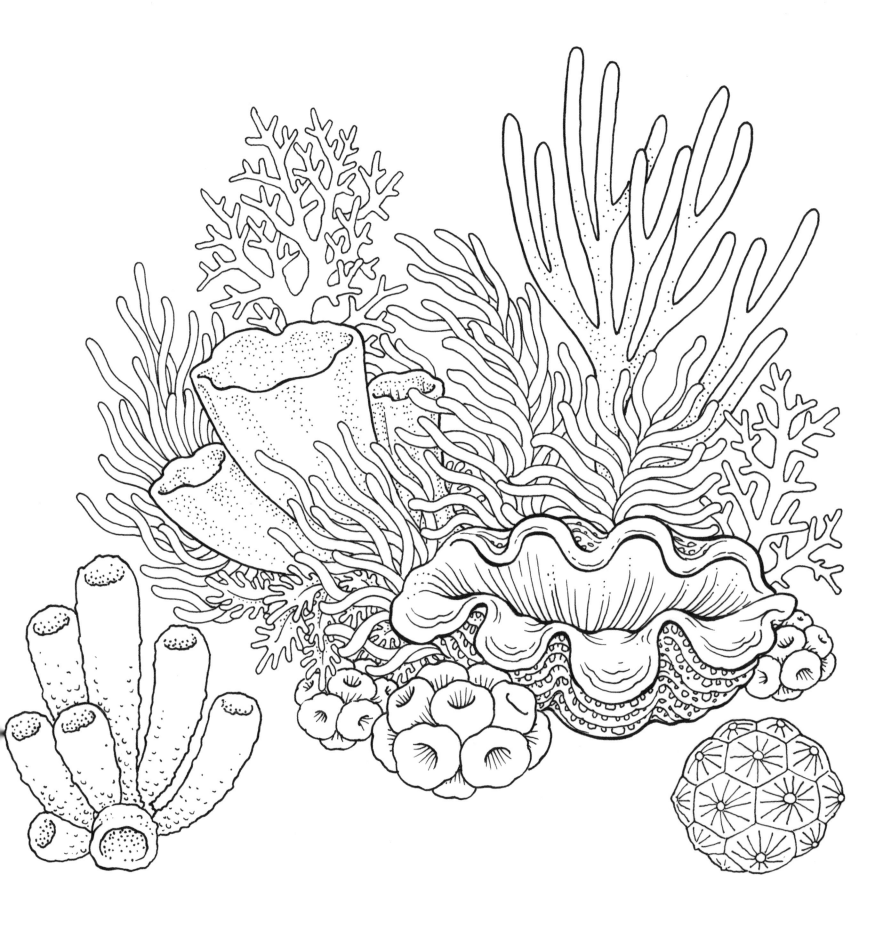

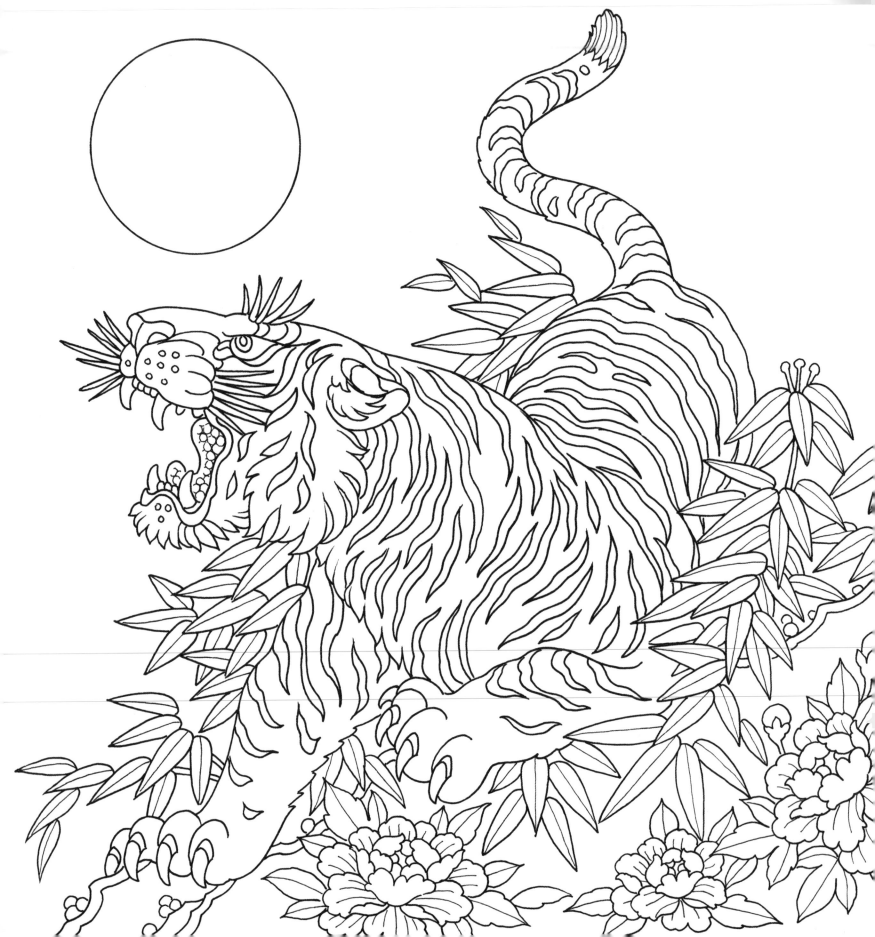

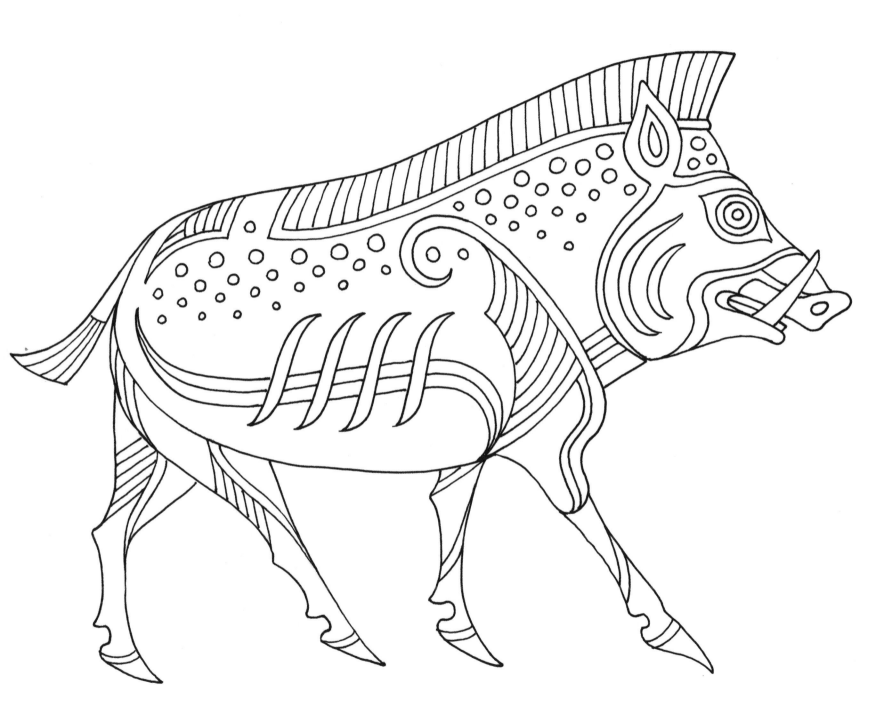

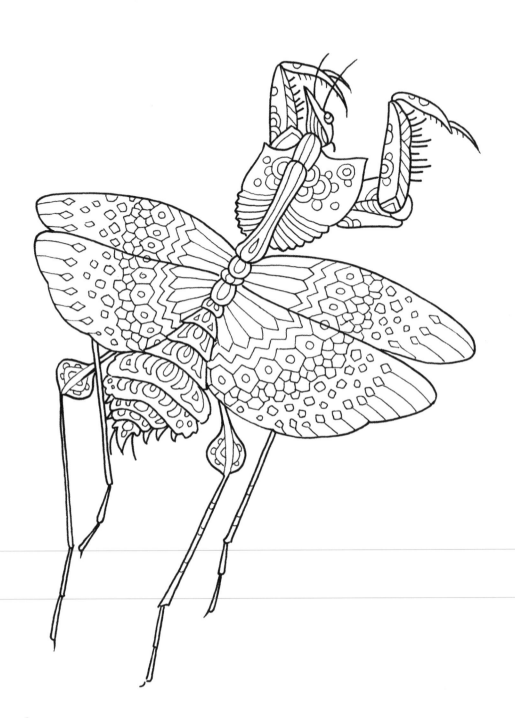

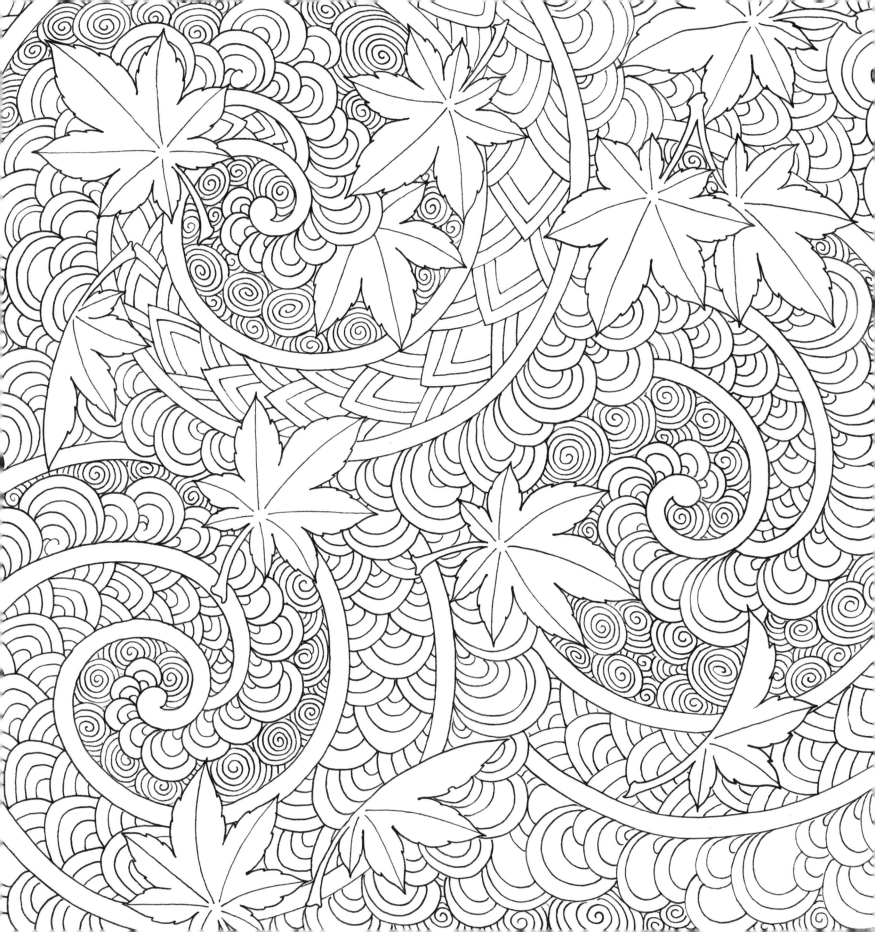

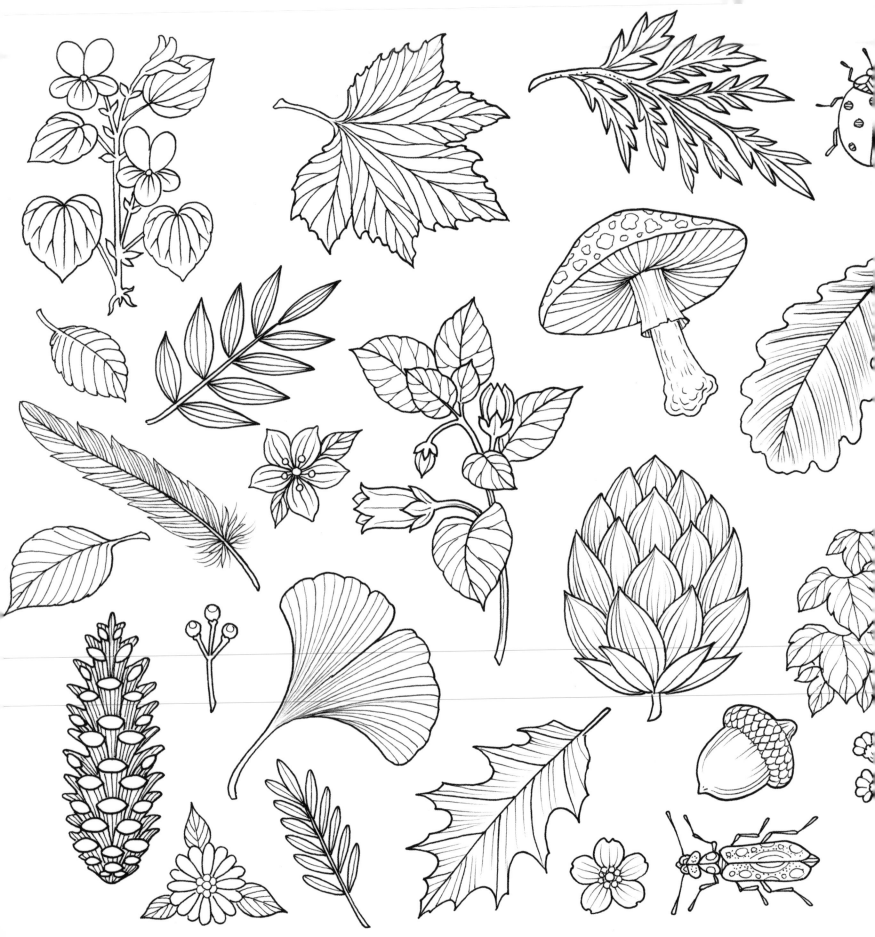

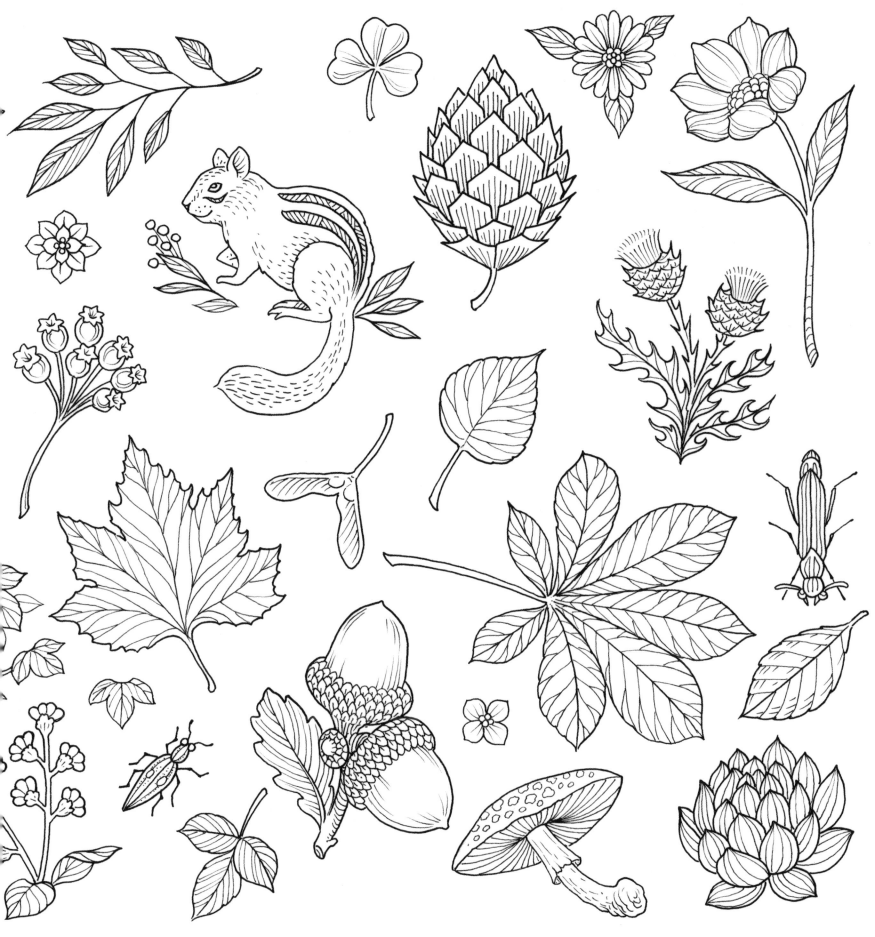

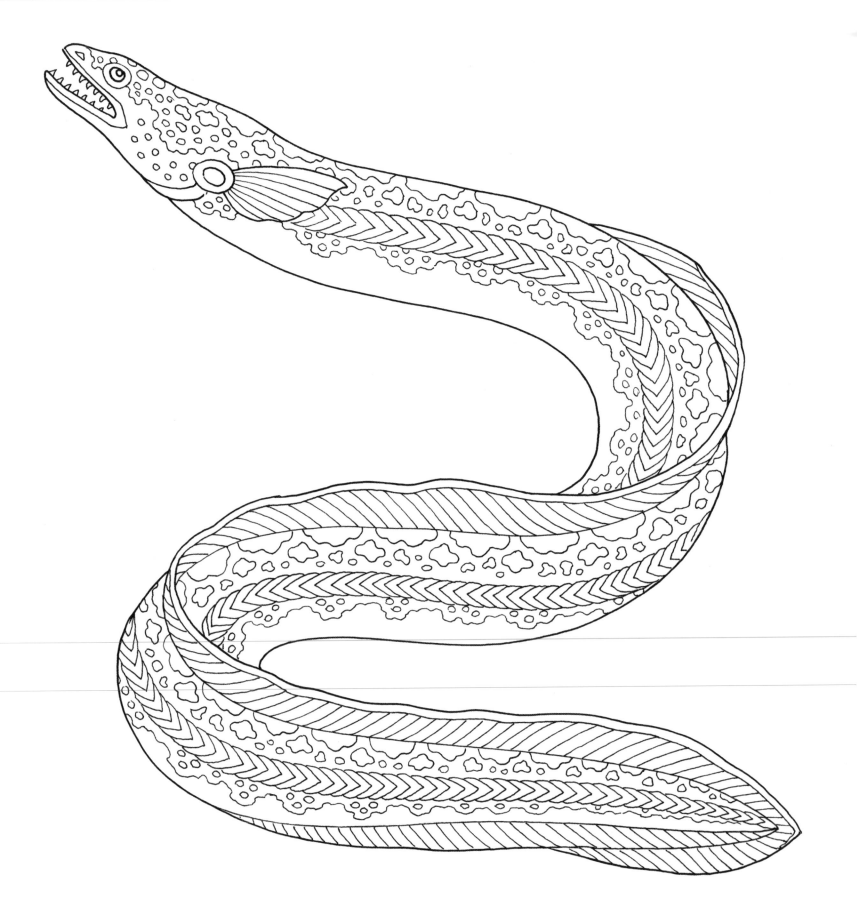

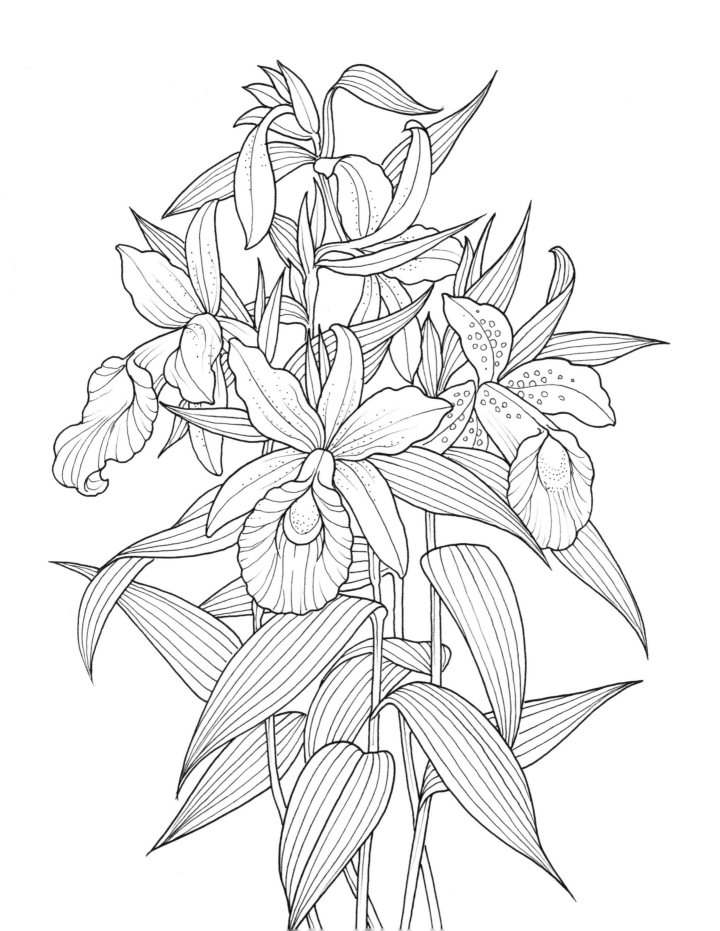

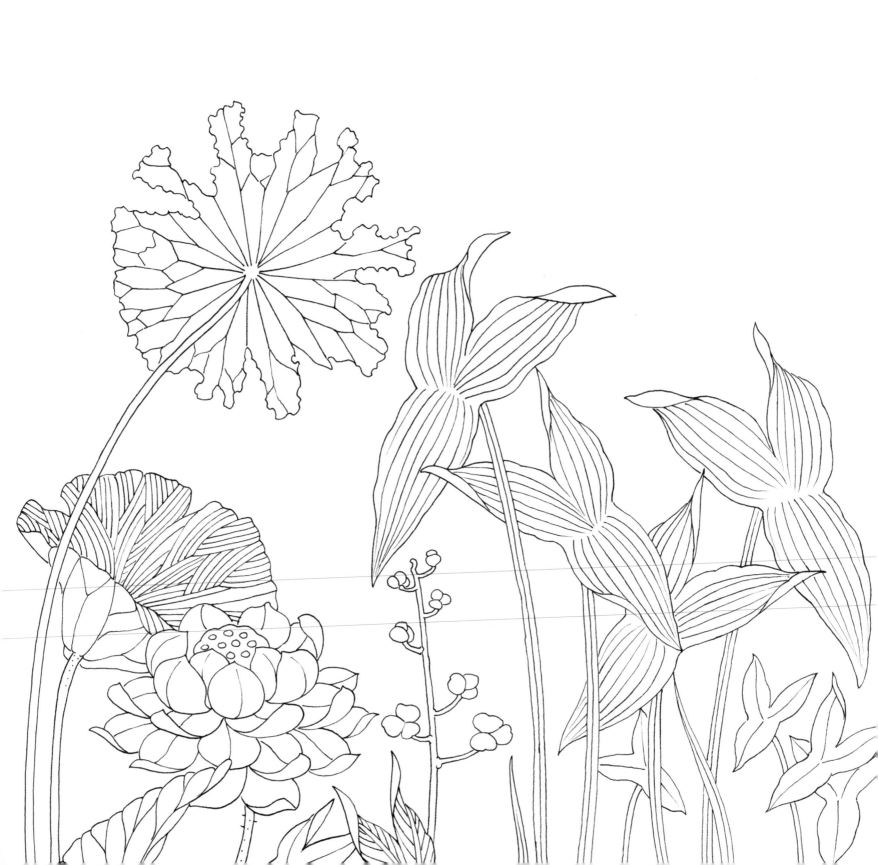

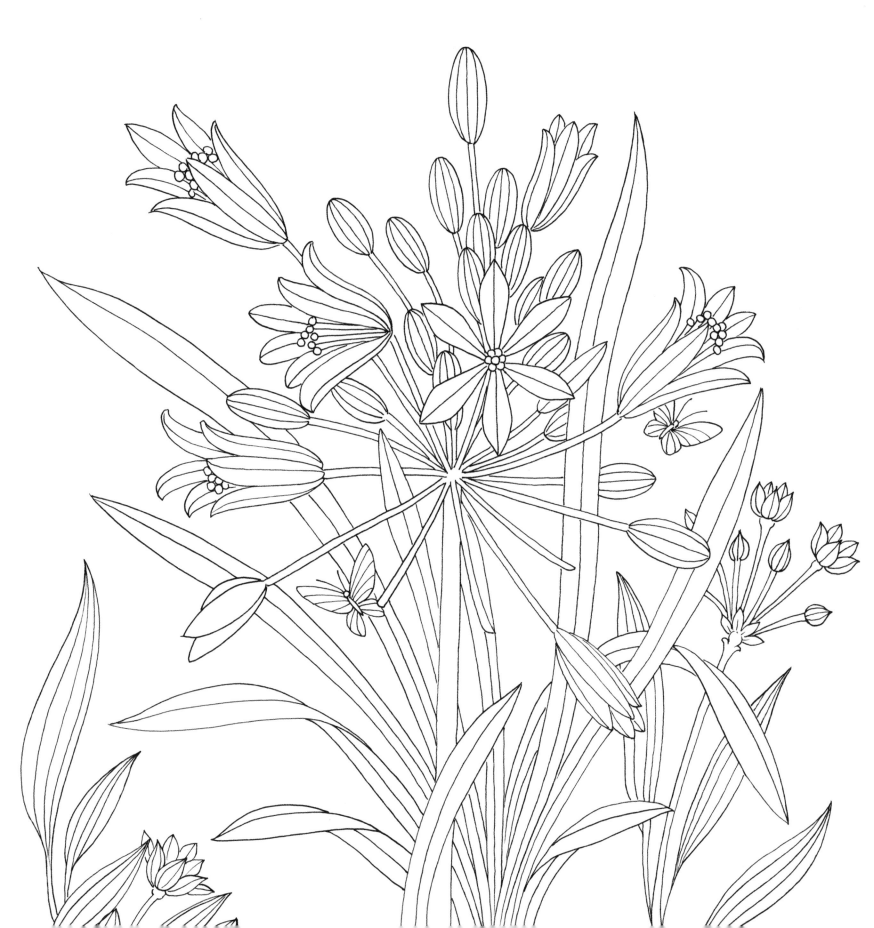

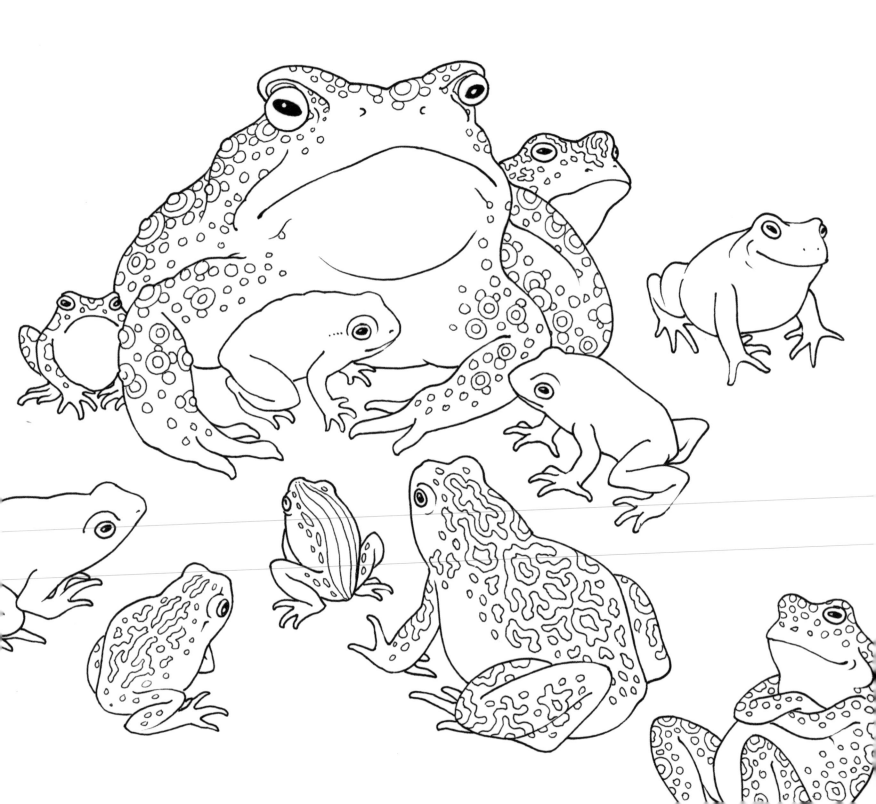

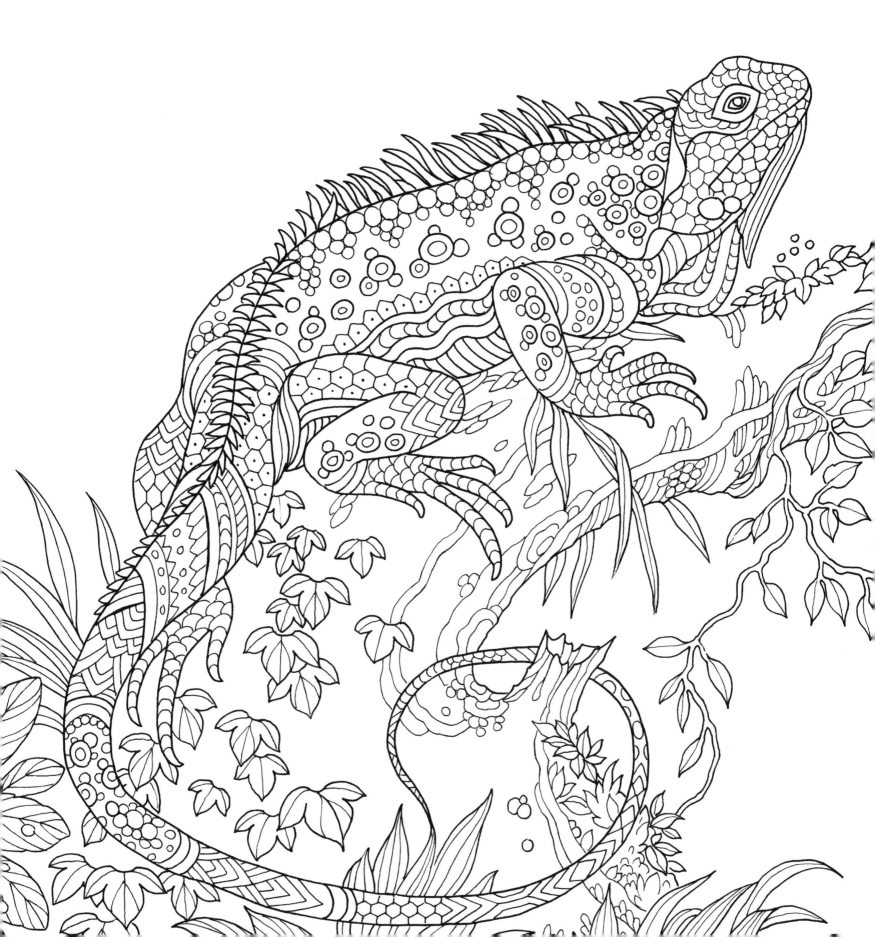

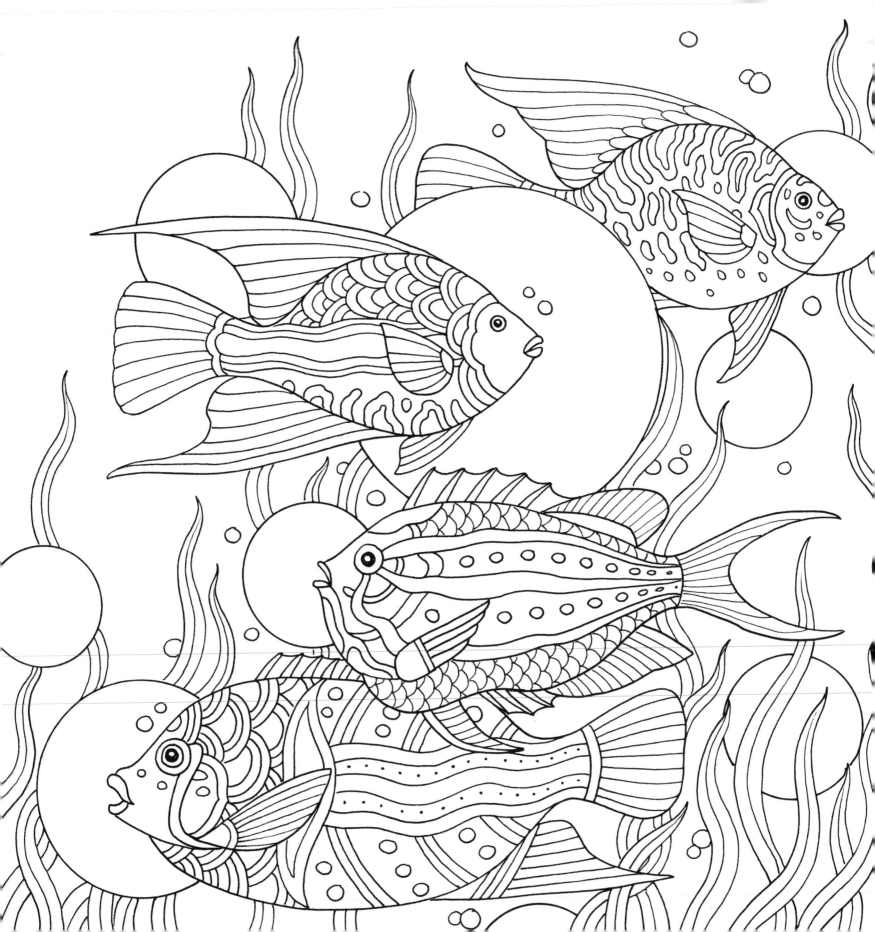

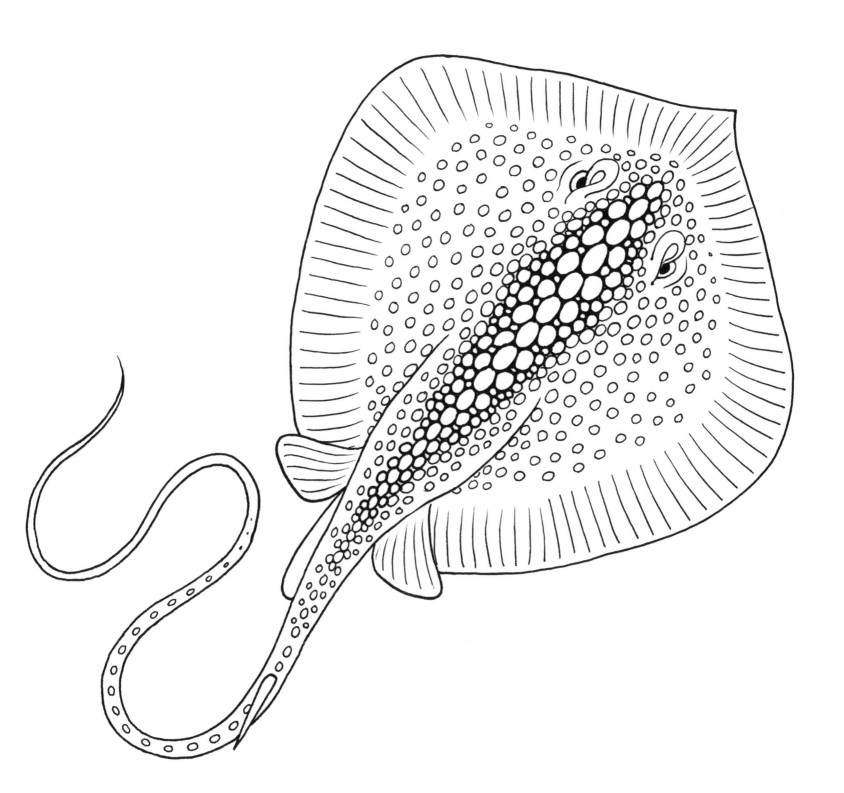

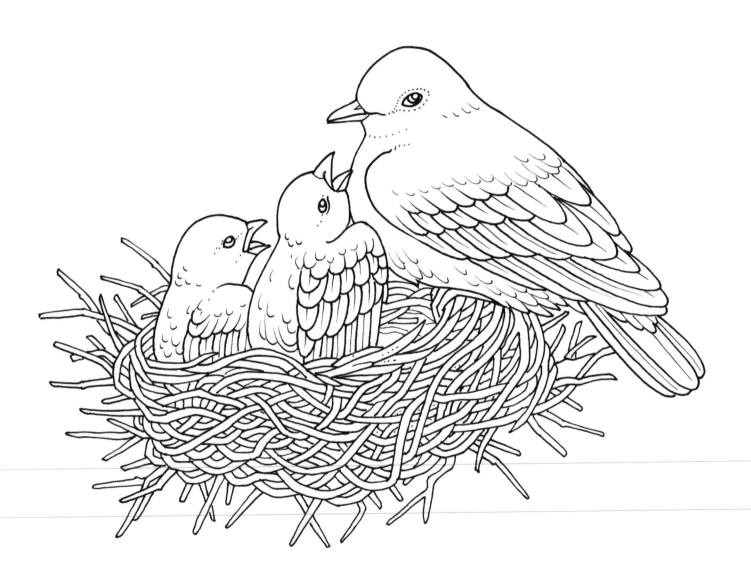

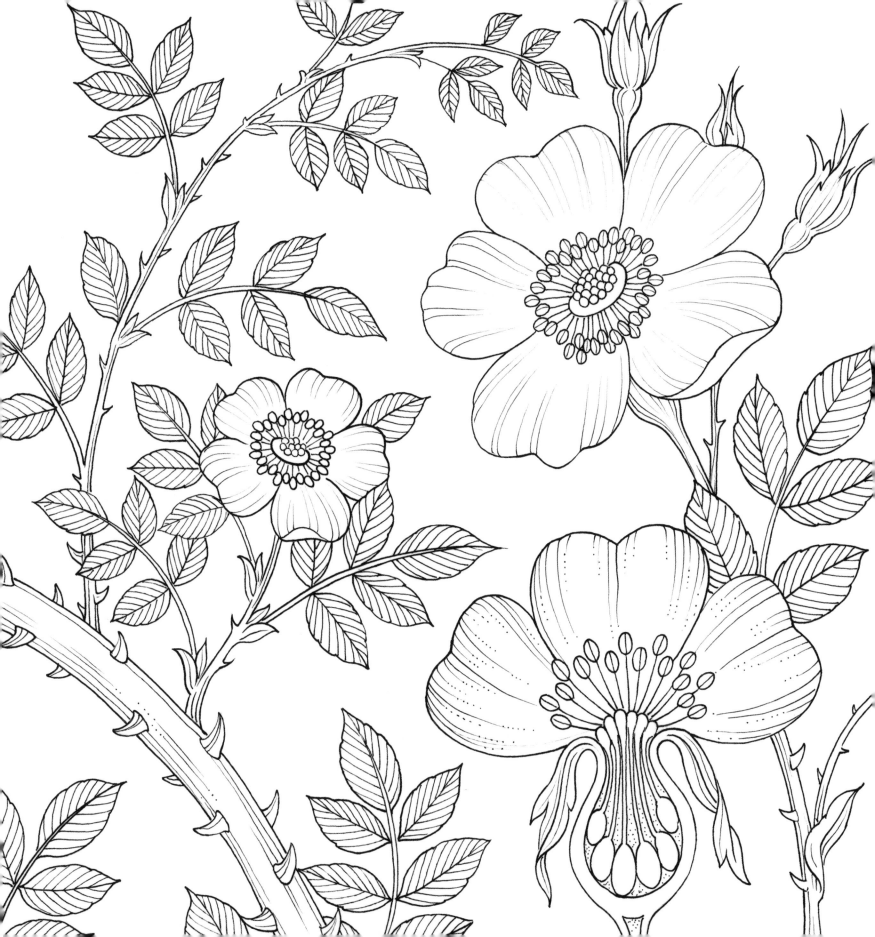

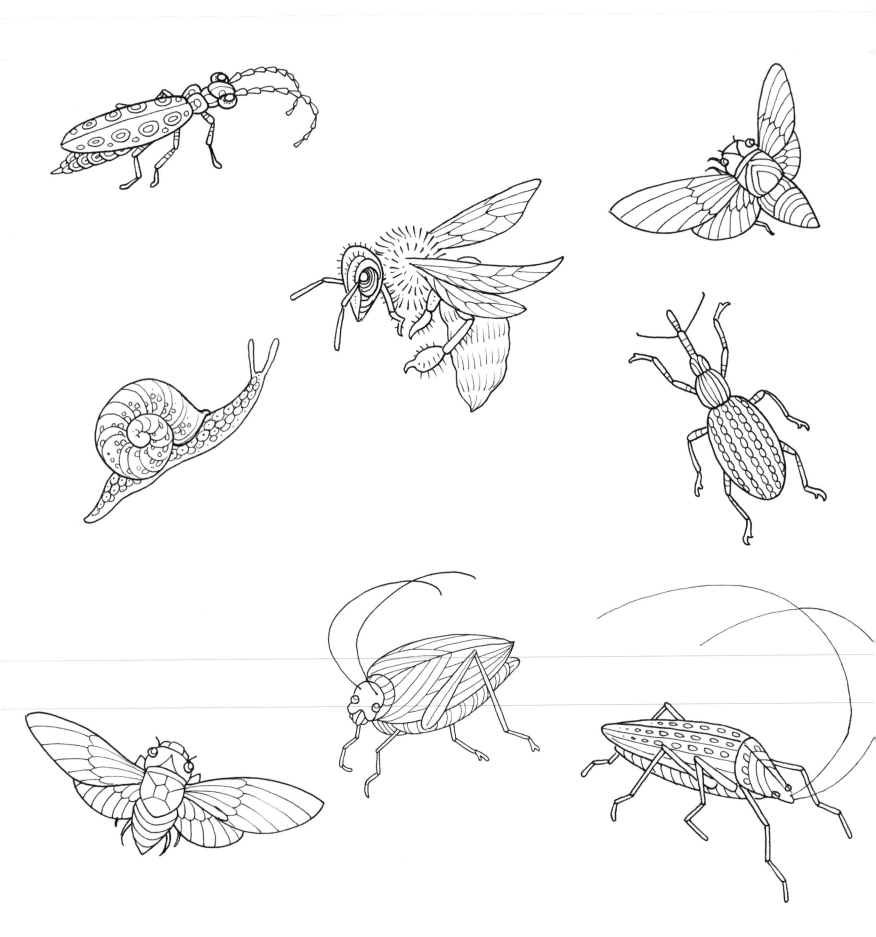

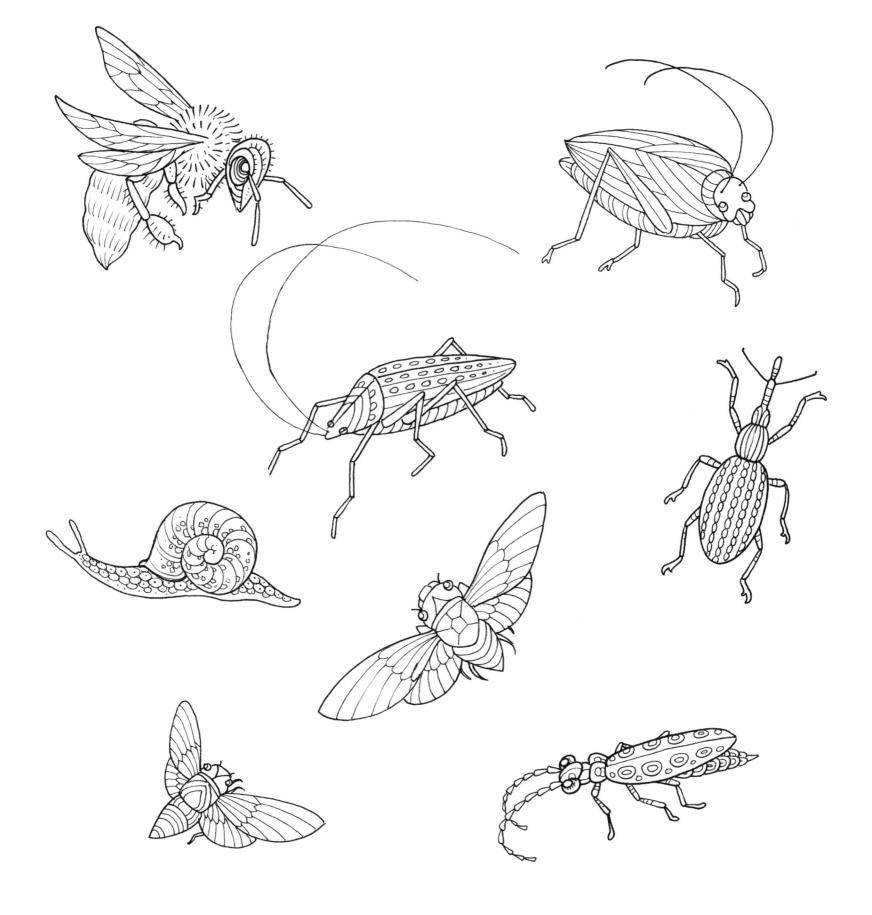

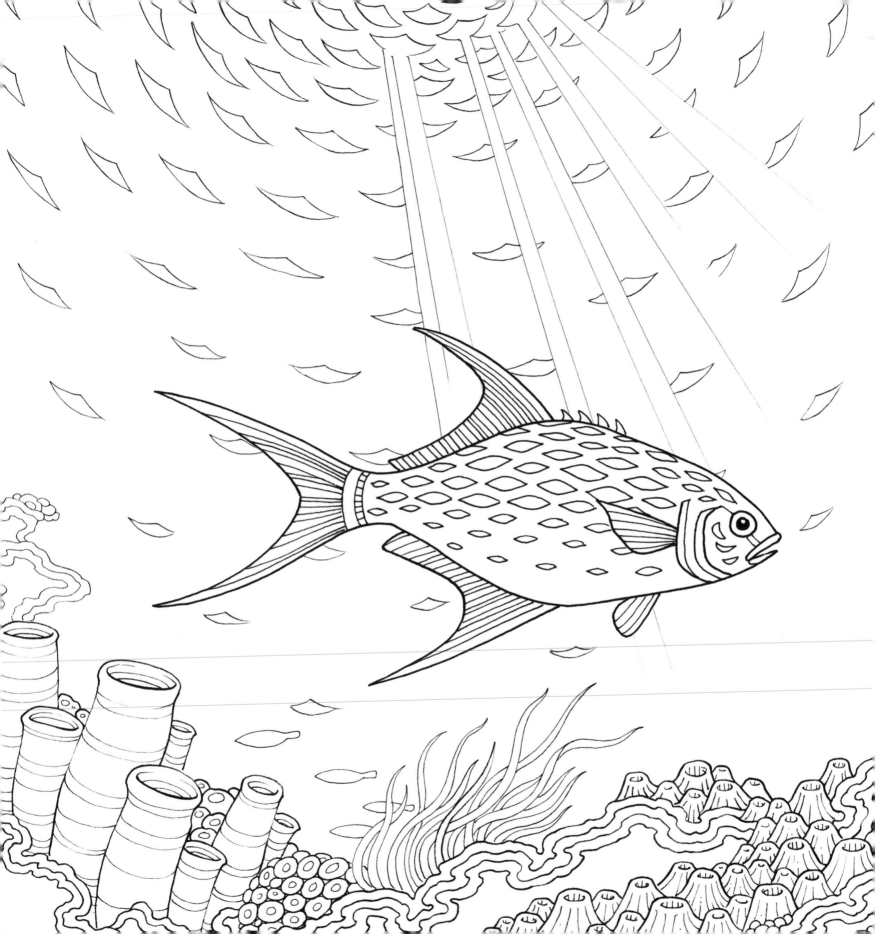

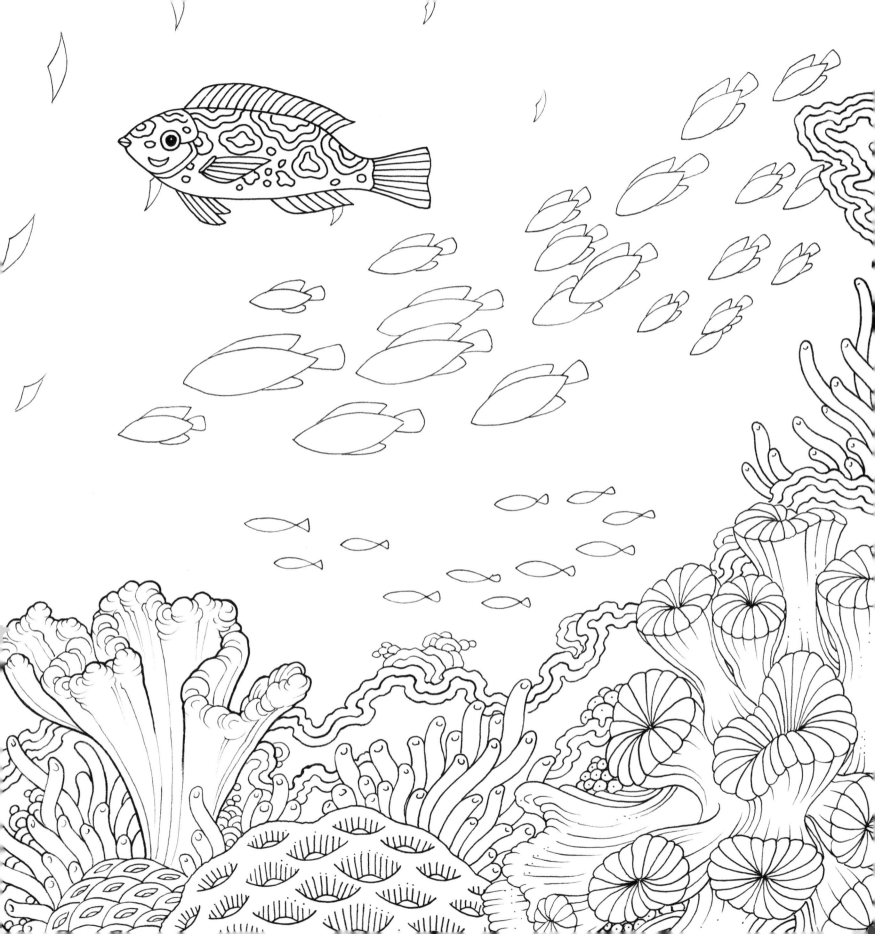

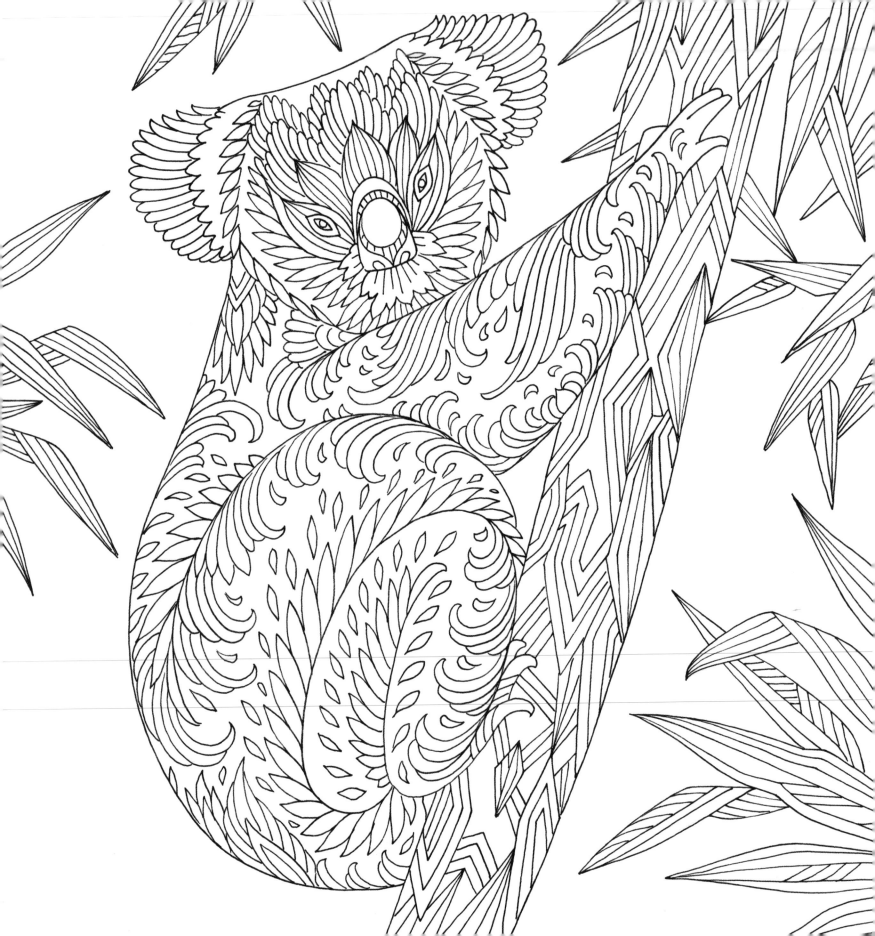

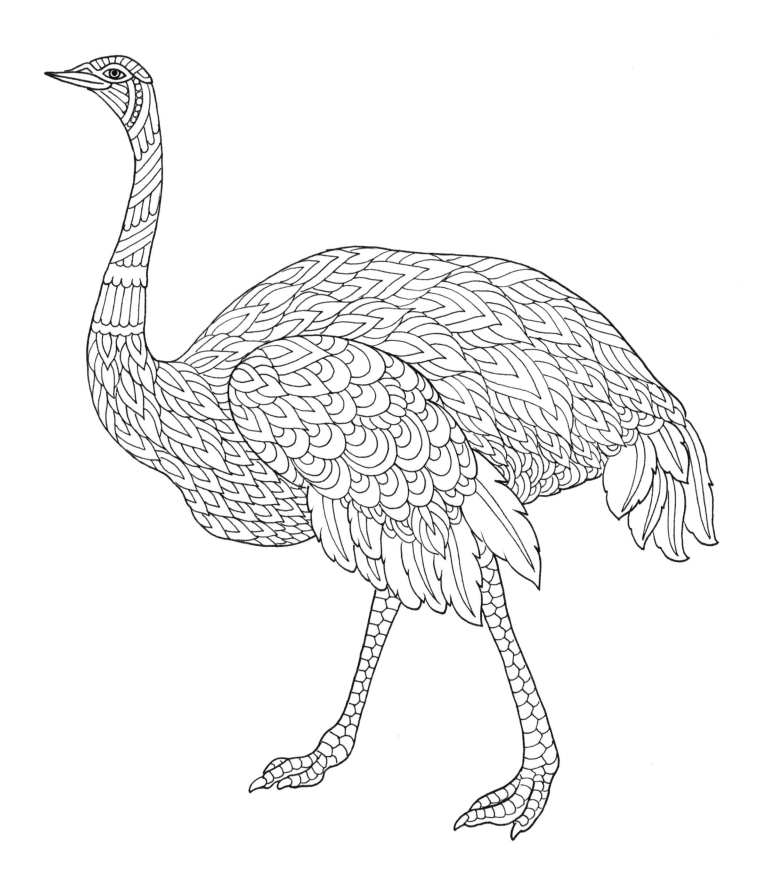

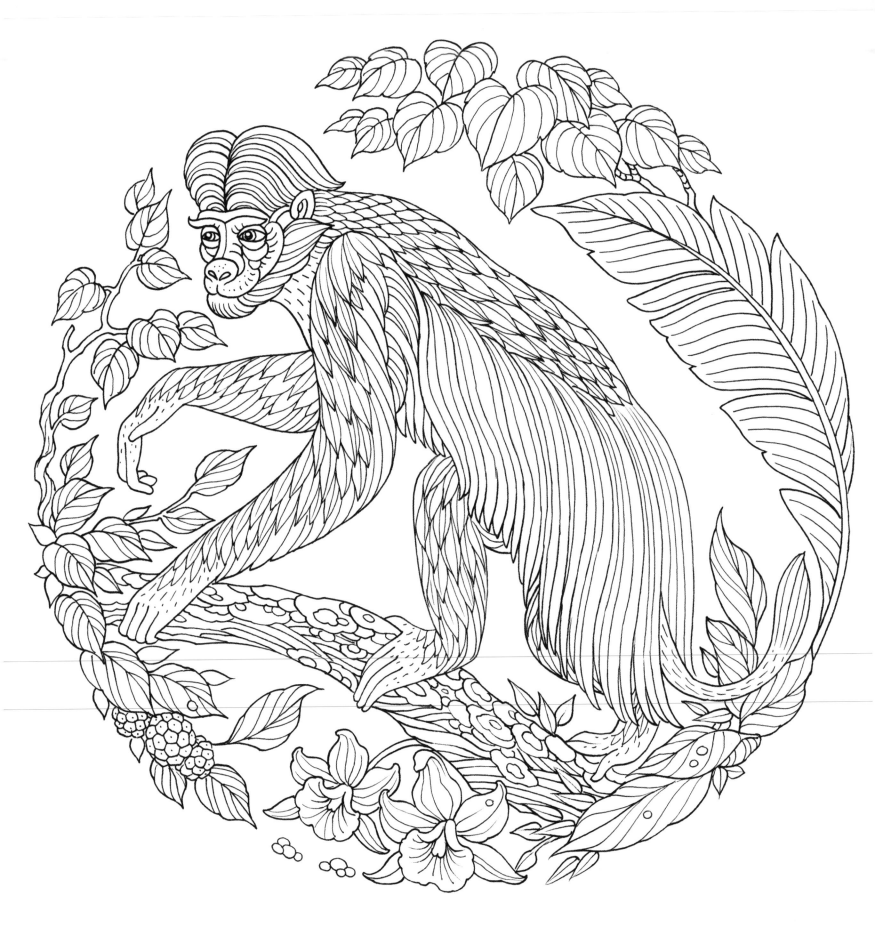

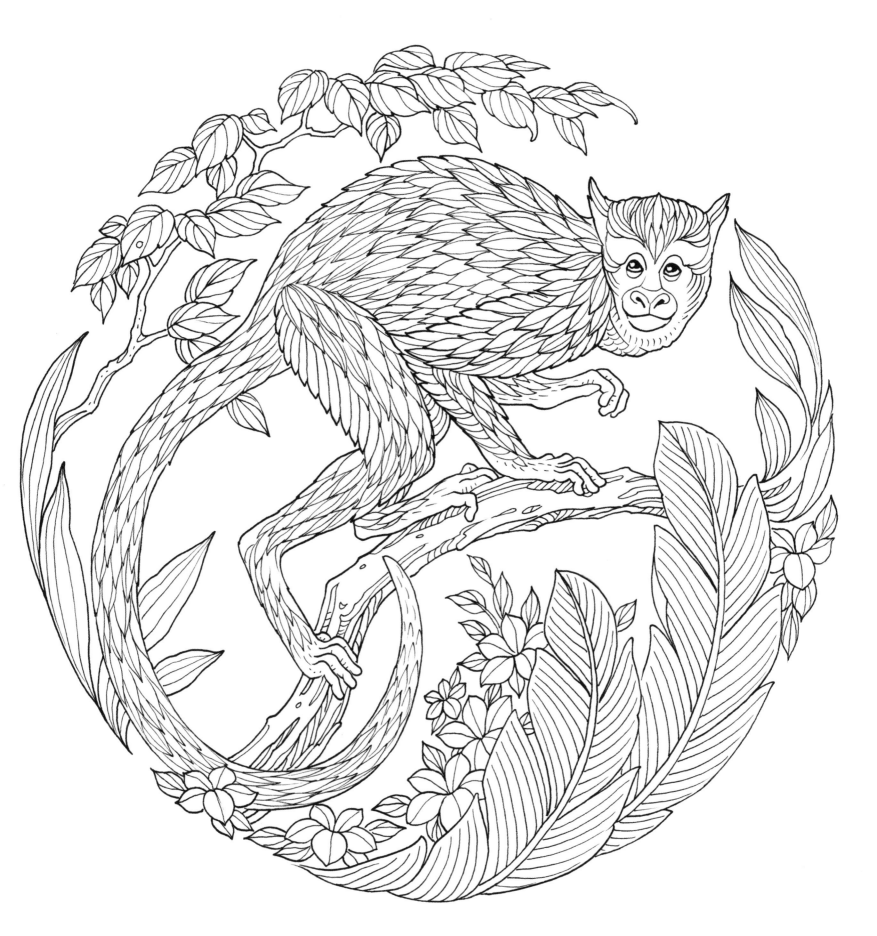

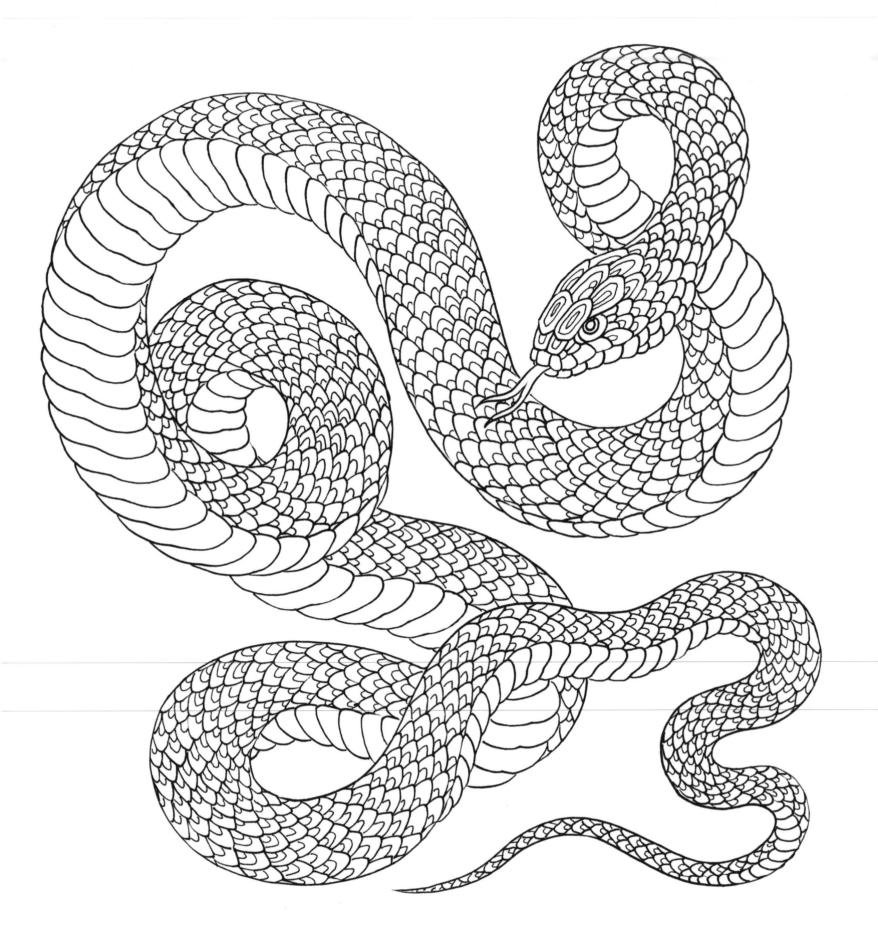

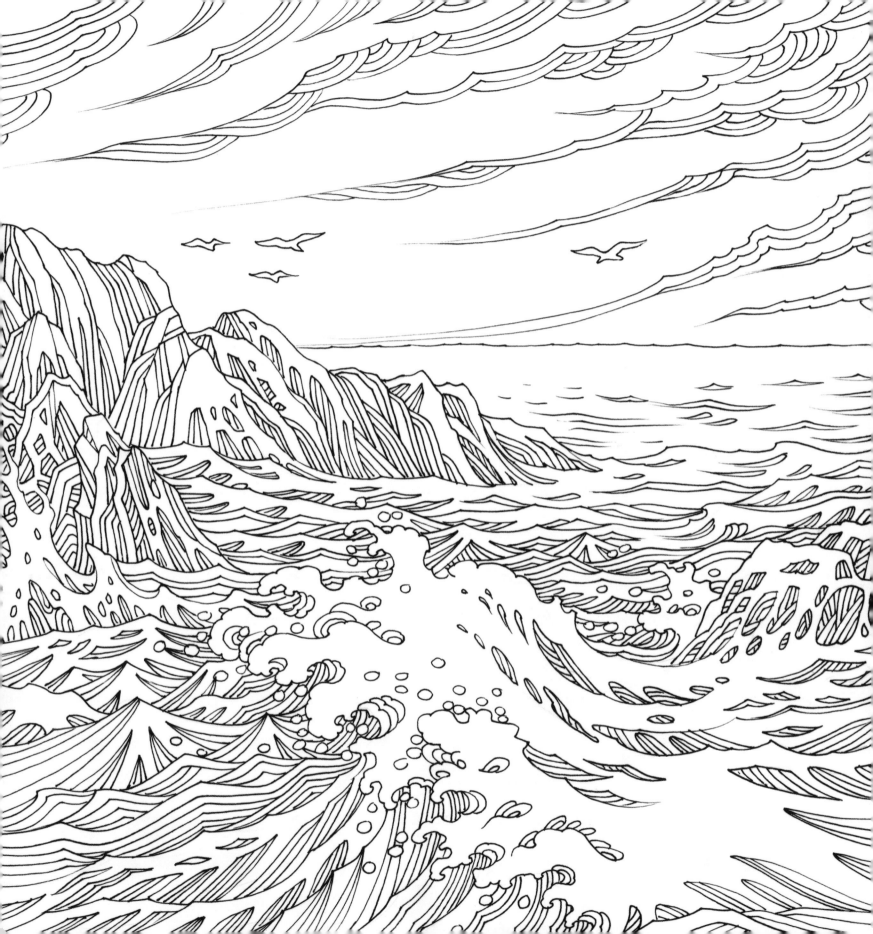

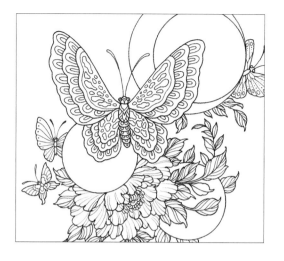

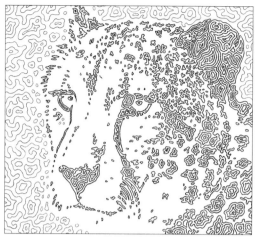

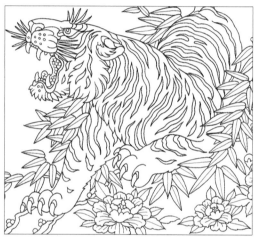

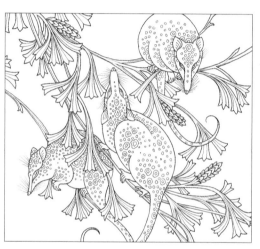

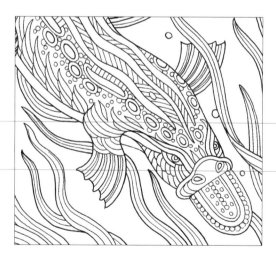

Butch Hogan Photography

Get Creative 6
An imprint of Mixed Media Resources
19 West 21st Street, Suite 601, New York, NY 10010
sixthandspringbooks.com

Connect with us on Facebook at
facebook.com/getcreative6

Manufactured in China

7 9 10 8 6

First Edition

ABOUT THE AUTHOR

Well known and respected throughout the tattoo community, Chris Garver garnered mainstream attention after appearing as a regular on the reality-TV show *Miami Ink*. A native of Pittsburgh, Pennsylvania, he attended the Pittsburgh Creative and Performing Arts High School and, later, New York's School of Visual Arts. An avid traveler and aficionado of all styles of tattoos, Chris has visited and worked in such locales as Japan, Singapore, England, and the Netherlands. He currently resides in New York City with his daughter, where he owns a tattoo shop called Five Points Tattoo.